GLORIA PLEVIN

art and essays

Gloria Plevin

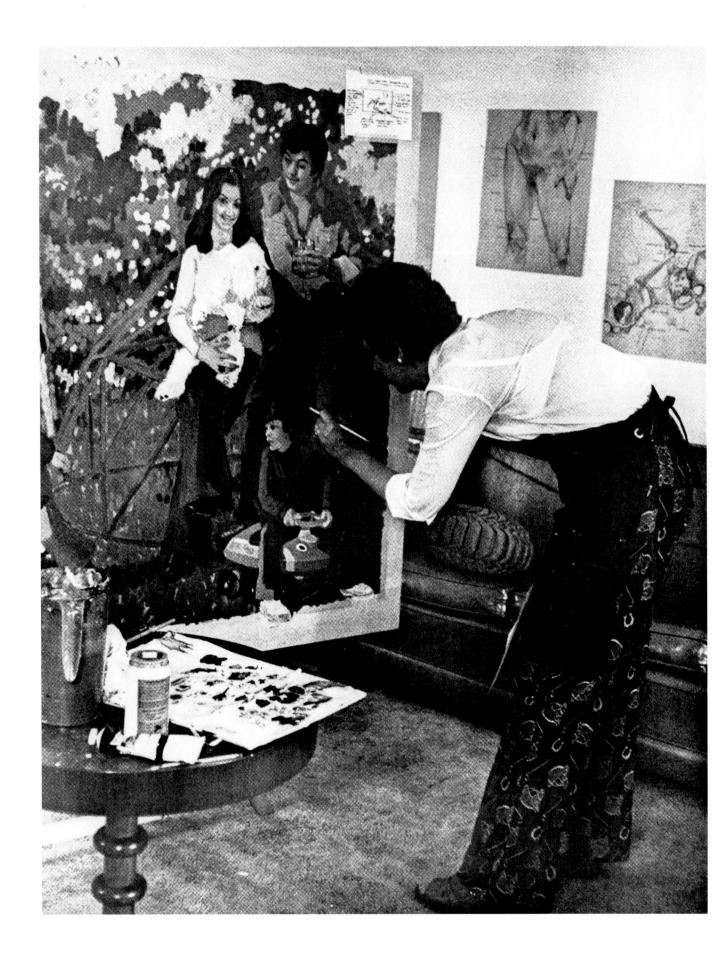

Gloria, in Home Studio
Photo by Barbara Weiss, 1976

Dedicated

to

my children

and grandchildren

and especially

Leon Plevin

whose motto

was

Dare in your own

adventure.

Published by ARTneo, Cleveland, OH

Forward by Christopher L. Richards
Introduction by William Busta
Edited by Mimi Plevin-Foust
Design by Joyce Rothschild

All essays and works by Gloria Plevin

$24 and a Watch by Mimi Plevin-Foust

© 2019 ARTneo: The Museum of Northeast Ohio Art
1305 W. 80th Street Cleveland, OH 44102
www.artneo.org

ARTneo programming is made possible by memberships and
support from: The George Gund Foundation, The William & Gertrude
Frohring Foundation, The Cleveland Foundation, AG Foundation,
The David & Inez Myers Foundation, 78th Street Studios, and
Baker Hostetler.

Photographs of art: Al Fuchs, Wade Gagich, Christopher L. Richards

Front cover: *Backyards Chicago* 2002
Reduction linoleum block print 18.5 x 23.5 inches

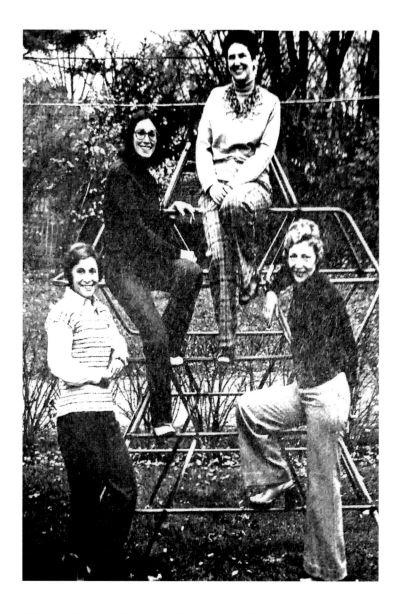

'Pots, Paint, Prints, Pen' exhibit artists:
Doris Sugerman (lower left), Suzanne Gilbert
(upper left), Gloria Plevin (top),
Bea Blumenthal (bottom right)

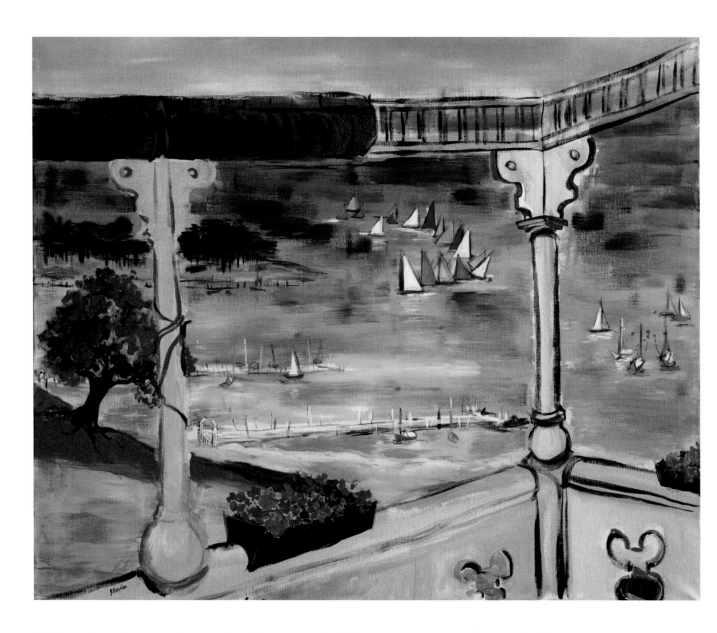

What is it that makes each of us special? This is amazing to me. Each creature is unique and feels that he or she is the center of the world. We are set on a path— each person, each bird, each animal, each flower—is set on a path which has similarities to the path of others of its kind, i.e., growing, maturing, mating, procreating, aging, dying.

If I have a spirituality, it has to do with my recognition of a plan that is so vast, so exquisite, so creative, that it is beyond any comprehension.

Gloria Plevin
April 2018

FORWARD

The process of selecting work for ARTneo's exhibition *Gloria Plevin: A Life in Art* was like stepping into her shoes and traveling through a visual exploration of her life. With a keen artistic sensibility, she imbues each piece with an expression of the personal. I chose to include works that would tell the most complete story possible—a story in which Plevin celebrates her friends and family, the places she loves, and the beauty she finds in the arrangement of everyday objects and flowers.

ARTneo was proud to exhibit 60 of Plevin's paintings, prints and pastels last spring, and this year we are proud to highlight that exhibit and more by publishing *Gloria Plevin: art and essays,* an extensive catalog of her distinguished career in art. Both Gloria and her late husband Leon have been long-time ARTneo supporters, serving on the board and as advisors. We thank her for her continued support of our mission. Such a large retrospective could never have happened without her help. Her daughter Mimi Plevin-Foust also provided invaluable assistance with organizing information and publicizing the exhibit.

Finally, I would like to thank ARTneo's board for helping to make *Gloria Plevin: A Life in Art* a success. From the exhibit's inception, Joan Brickley provided guidance and encouragement. She helped arrange initial meetings and coordinated communications. We are grateful to William Busta for his insights and research and for writing the introduction to this catalog.

Through her art, Gloria Plevin invites us into her world to see what she sees and what she thinks is worth attending to. For this reason, it is perhaps best to allow her to discuss her work in her own words. In this book, Plevin's essays, insights, and musings provide the viewer and reader with a more complete picture of not just the art, but the artist herself.

Christopher L. Richards
Curator

Chautauqua Porch Looking at Lake (left) 1969
Acrylic 36 x 40 inches

INTRODUCTION

Gloria Plevin: Art and Essays

Like the breath of memory, the works of Gloria Plevin present a moment gracefully imagined and conscientiously realized in a personal consideration of time. In that time there is stillness and then a presentation, and then something of reflection. The works hold that stillness as a meditation without intent to surprise or disturb. But there is cautious mystery that takes from the world and rearranges purposefully and personally — a world that can be touched, yet is tantalizingly elusive to the grasp.

The elusiveness in her work suggests a flirtation with the magic realism of the 1940s and 1950s and then finds affirmation in her intimate relationship with her subjects. Her interior portraits or flower studies or landscapes are personal rather than academic; they are the life around her that she has created and observed. Her work finds expressive beauty in her surroundings, familial relationships or quiet consideration. In some ways it is a reduction: it is not the world that we are seeing, but the world that she sees. Her painting or drawing is entirely possessed by her eye.

Gloria Plevin was born in 1934 in Pittsburgh, Pennsylvania and was raised in a small city in West Virginia, a community that was reassuring as well as limiting in its boundaries and expectations. In furniture shops along the main street, she enjoyed studying design detail and styling. While working on her Associate Degree at Ohio University in the early 1950s, she balanced her business classes with introductory, then advanced classes in art. After graduation, like many natives of West Virginia in the 1950s and 1960s, she migrated north to Cleveland, seeking a larger world with more opportunities. Gloria Plevin's intent to be an artist followed her life like a promise to herself, held close, ever present, as she worked at Sterling Linder department store in Cleveland, married Leon Plevin, and had children.

In 1968, that promise began to be realized as her family began spending summers at the Chautauqua Institution on the lake of the same name in western New York State. Chautauqua was founded in 1874 and soon became a nationally-renowned summer

gathering for people interested in broadening their knowledge of issues of the day, deepening their spiritual lives, and expanding their capacities to perceive through the arts. Even today, it is a unique summer place — a utopian intellectual and spiritual village of Victorian and Edwardian houses.

Gloria Plevin first came to Chautauqua because she had friends who vacationed there and enjoyed the atmosphere. She and Leon rented a house and soon her family was staying every summer. Her art blossomed with classes and studio time in the mornings. In 1985, they bought a house nearby and opened a summer art gallery.

From the start, she found expressiveness and comfort in rendering through the classroom exercises and was ambitious in developing facility with the tools and skills of artmaking. Even so, she knew that what she wished to create was out of favor with the procession of the art movements of her time. With fundamental insistence, she distanced her work from curators and

critics who celebrated the heroic and monumental of abstract expressionism or the intellectual cool of geometric abstraction. She chose, like many others, to create works that directly referenced their subject, what cultural curator and advocate Lincoln Kirstein has described as "painted equivalents transformed through selective imagination."

Insistent, with her own clear vision, over time, her content moved from the immediate to the expansive—from portraits and still-life to her gardens and then to the landscapes of rural Chautauqua County. Those landscapes are lush in noonday summer heat, brisk with bounty of harvest, restful under blankets of snow, and bright with the new growth of spring.

The landscapes are at once familiar but entirely hers. She shows us the road and gives us direction. But, even as viewers, we need to follow the advice she once wrote to herself, "The lesson that I did learn is that...I had to find my own way."

William Busta

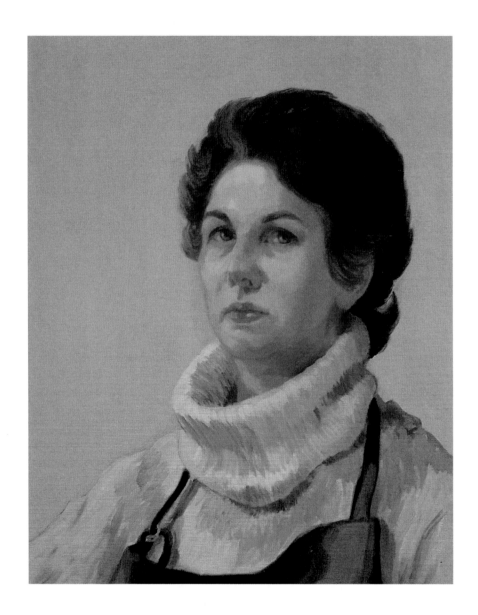

My paintings and prints are about life, and I use people, plants, fields and objects in compositions where shapes and colors help create a certain mood. They are about paint and not about politics.

Gloria Plevin

Self-Potrait 1975
Oil 20 x 16 inches

PROLOGUE

Becoming an Artist

The bats swooping from the attic of the old house my family rented in 1968 during our first summer at Chautauqua made my nights like Hell, and I might have given up and gone home to Cleveland except that the days were like Heaven. Our landlord's first instruction had been, "Never kill a bat. Each bat eats 1,000 mosquitoes a night." Seven different bats visited us that summer, and each bat was carefully covered, slid off a wall onto a plate, and escorted out the door.

For several weeks, at 8:30 a.m., I left my three-year-old Sarah with a babysitter and dropped my five-year-old Andrew at the Children's School; nine-year-old Ann went to Girl's Club, and 11-year-old Mimi went to drama class. For three hours, I attended a painting and drawing course at the Chautauqua Arts Quadrangle. For three hours, five days a week—fifteen hours in all—I was totally happy.

Revington Arthur, the Chautauqua Art School director who was also our teacher, was an older man from Connecticut who favored Bermuda shorts. Several assistants attended to students from age 18 to 80. Regardless of age, each student eventually revealed talent. This was a portrait class and the models varied. A handsome young man, a heavy-set middle-aged woman, a slim pretty girl, and so on, provided variety and challenge. Nobody spoke as we worked, but before and after class, we became acquainted.

At ten, we took a break and a few of us would wander down the steps to a small room for coffee. There, we chatted with Mr. Arthur who turned out to be a savvy working and teaching artist. We talked about the national shows and one in New England which he had founded. Mr. Arthur's work had been in the renowned Pittsburgh International. And he was friends with many nationally-known artists including the Ashcan School painters who depicted New York City's street life.

Friday was the day when the week's artworks were hung up, and we gathered around for the critique. This was my first experience in my art being evaluated: I dreaded what might be coming. Mr. Arthur may have been harder on the guys, but he was gentle and frank in his comments about my portraits. He said my drawing was ahead of my painting, but that it would get better with time and work. That class was the beginning of a mentoring relationship that continued for over a decade.

After several weeks, I had made pictures which felt good enough to enter into an exhibit of Chautauqua artists. I decided to enter the Bestor Plaza show as a professional. Lo and behold, several of my works received blue ribbons! What a boost to my fragile ego.

With new confidence, I went home that fall eager to learn. I began to attend serious weekly classes: one night at the Cleveland Institute of Art and one day at the Cooper School of Art. And I set a serious goal for my 30-year-old self: a solo exhibition by the age of 40.

Gloria Plevin
April 12, 2018
Revington Arthur (1908-1986)

When I was a girl, I enjoyed reading stories written by the French author Collette.
What I recall are Collette's memories of outings with her mother. "Look! Look!"
her mother would say, pointing out this and that as they walked or drove about.

All grown up, I did the same with my children. "Look! Look!" I would say
from the time they were babies.

Now, to anyone interested in my paintings and essays, I continue to say,
"Look! Look!"

Gloria Plevin
January 20, 2011

Nasturtiums After Rain 1995
Pastel 20 x 26 inches

TABLE OF CONTENTS

Relationships .. 15

Sur La Table ... 47

Making Prints ... 67

Out and About .. 81

Flowers ..103

Snow ... 124

In Appreciation .. 148

Chronology ..150

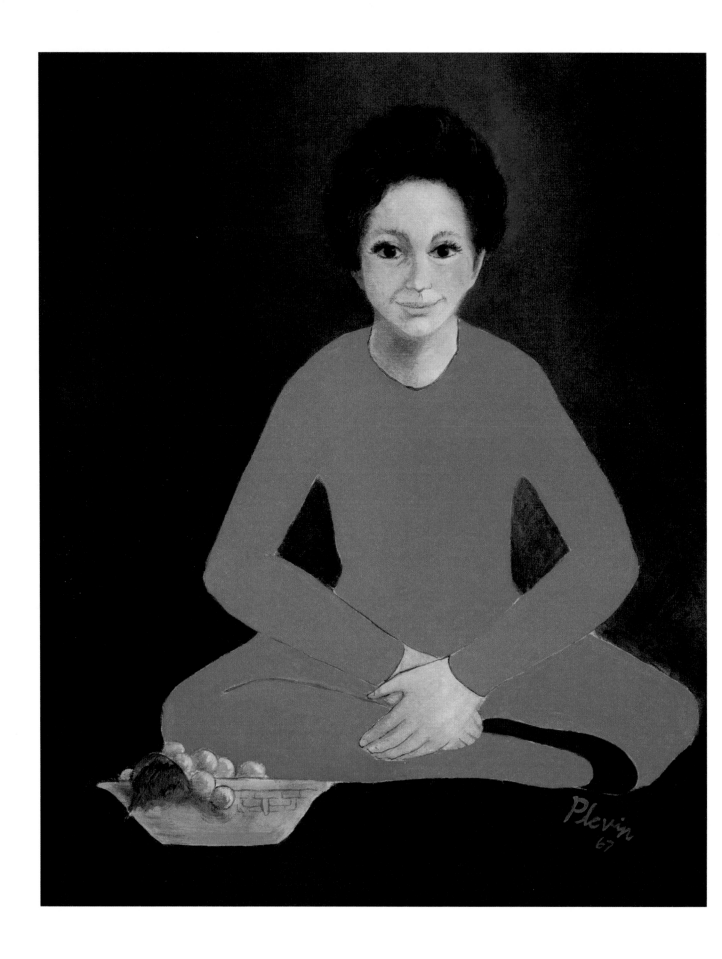

Annie in Leotard with Grapes 1968
Oil 24 x 20 inches

RELATIONSHIPS

Creating a Work of Art: Portrait of Annie

My first art class at the Cleveland Institute of Art was at night with instructor Daniel Hodermarsky. I had three little children at home. My husband Leon's requirements were autocratic but fair: Each kid must be in pajamas and fed dinner before I left the house. You bet, Leon!

In Hodermarsky's portrait class, I decided to paint my seven-year-old daughter Annie who was taking ballet lessons with her older sister Mimi. The picture would be of a little girl sitting cross-legged on the floor in a ballet leotard with a bowl of grapes — her favorite dessert — in front of her. Thankfully, my normally fidgety second child did not mind sitting still as I painted my first portrait.

When Mr. Hodermarsky looked at the painting I brought to class, he noticed I was nearly crying. "Why are you so unhappy?" he asked.

"Because," I replied, "I've tried and tried, and I'm not getting a good likeness of her."

"Now, you listen to me," he said earnestly. "In a hundred years, nobody will know if this image looks like Annie. They will only care if it's an interesting picture!"

Gloria Plevin

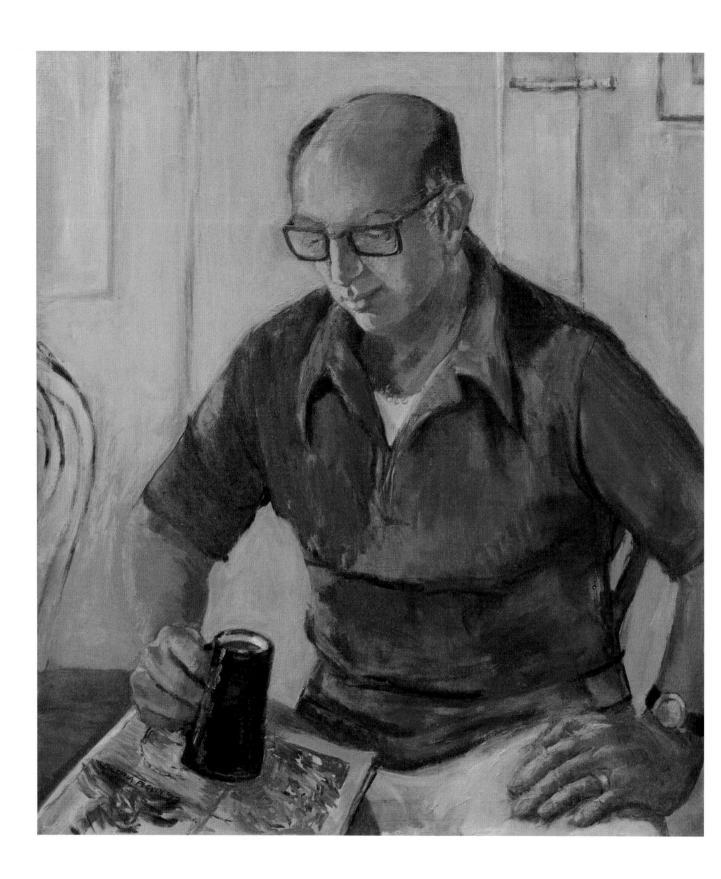

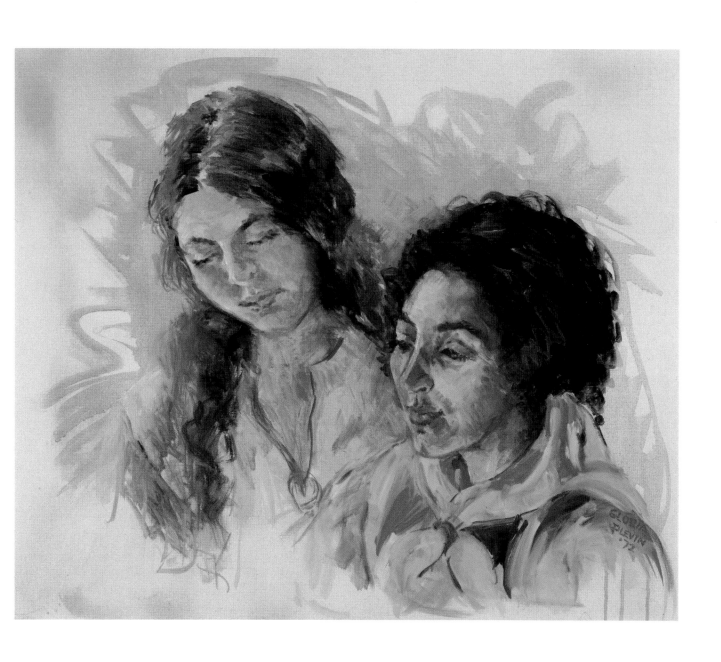

Leon and a Cup of Coffee at Chatauqua (left) 1973
Acrylic 28 x 32 inches

Mimi and Ann (above) 1972
Acrylic 21 x 25 inches

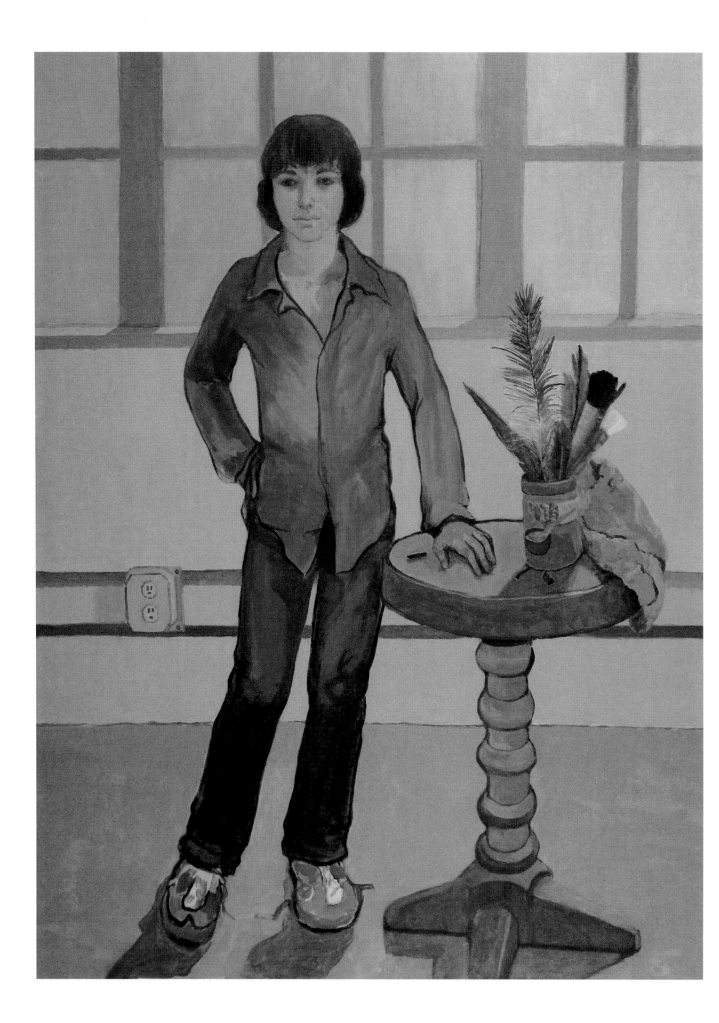

Portrait of Andrew

Since 2000, I have had the good fortune to share an artist's studio near downtown Cleveland that has Northern light, white walls and vast windows overlooking a sixth-floor view of Lake Erie. While searching the studio stacks in 2015, I was thrilled to discover a large painting that I'd abandoned and forgotten decades before: The full-length portrait of a boy standing with one hand on his hip and the other resting lightly on a wooden table nearby. He wore blue jeans, a blue shirt, and bangs--his hair long but neat, covering his ears, 70's-style. His tennis shoe laces were untied. He looked bored.

It was a portrait of my son Andrew. He was 11 when he posed in my home studio in our house on Shaker Boulevard. Now over 50, he's the father of four, a loving husband to his second wife Kendra Collins, accomplished in his field of finance, and in all ways, a fine human being.

The vaguely swished-around paint in the background reminded me why I had put the whole thing aside: I didn't know what to do with it. But, now, "the little gray cells" (as Hercule Poirot liked to say) began to percolate.

The picture spoke to me, telling me what to do next, as I returned to the studio every day to paint in a new background. Inspired and confident, I proceeded to paint the windows with their metal frames catching bits of light out of an exquisite blue sky. A flowered cloth and paint brushes in a soup can on the table, balanced the weight and curve of Andrew's figure. An electric wall socket anchored the background. Two light purple shadows connected his tennis shoes to the floor. Inspired by the spare background of my downtown studio, in a couple of weeks the painting was finished, after it had languished for 40 years.

Gloria Plevin
November 7, 2015

Andrew at Eleven (left) 2015
Acrylic 48 x 35.5 inches

A Lesson from John Pearson: Sara in a White Nightgown

When my friends invited their friend John Pearson, a popular and successful English artist, to privately critique our artwork, I was a young mother of four taking classes at both the Cleveland Institute of Art and Cooper School of Art. John had been guest teaching at CIA and now taught at Oberlin. He agreed to come to Cleveland every few weeks, driven by his artist wife Audra Skuodas.

We met eagerly in our homes with new work for each critique. Those meetings challenged us to work hard and regularly to receive the opinions of John and our peers. It was exhilarating but daunting to have Pearson's keen intellect and talent at our disposal for a few hours. Being of thin skin and easily discouraged, I was anxious about showing him the portrait of my young daughter Sara in a white nightgown, sitting barefoot on a little antique chair. The colors were cheerful oranges, greens and white.

John was kind but firm. "The colors are not suitable for this delicate picture of a child. Repaint it!" I was totally unprepared for his comments. Nevertheless, I made up a new palette of colors—soft blues, purples and whites—and then repainted the entire canvas. At our next critique, Pearson approved my changes. Sara in a White Gown continues to be one of my favorite and most successful portraits.

This period of devoted art-making catalyzed by Pearson's advice, spurred my growth as a painter. Making personal contact with serious, hard-working professional artists and seeking their opinions, was invaluable to my maturation.

Gloria Plevin

Sara in a White Nightgown (right) 1976
Acrylic 36 x 24 inches

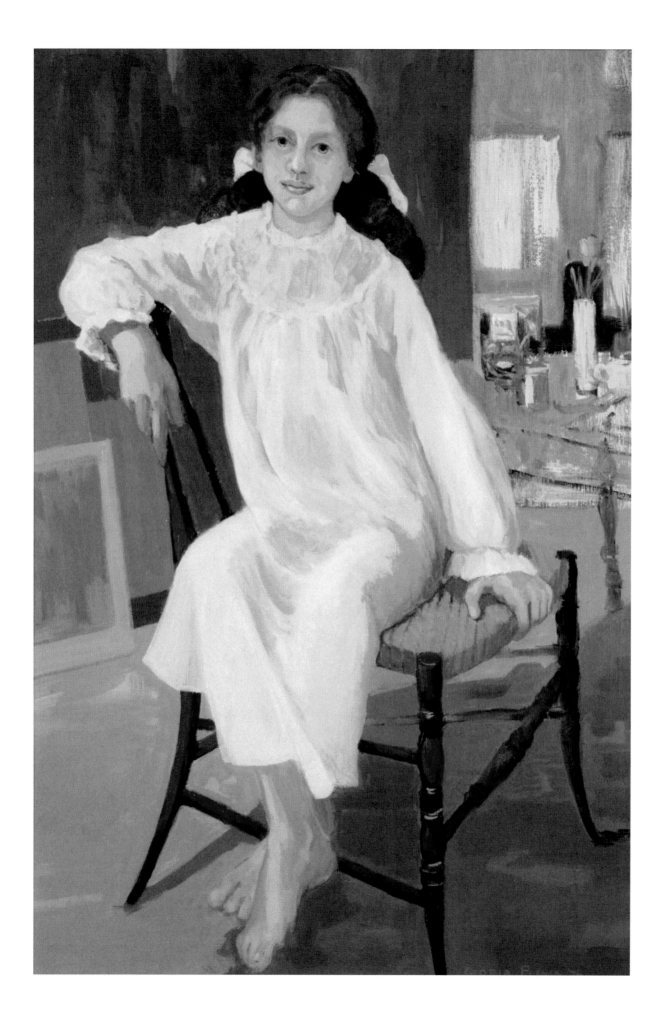

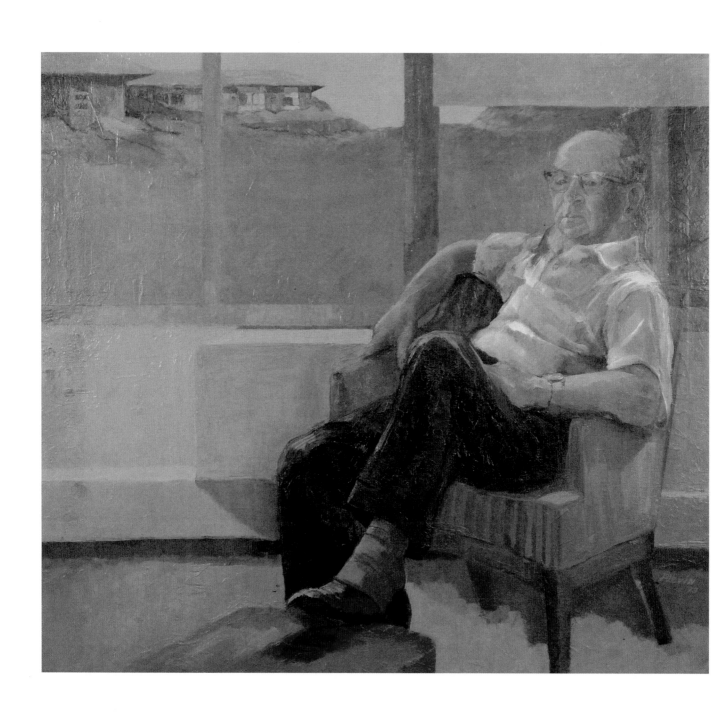

Ben Plevin at Council Gardens 1973
Acrylic 36 x 40 inches

$24 and a Watch

Grandma Rose gave us shiny white underpants with a pink embroidered rose the week she toilet-trained my sister Ann.

.......

"Eenie meenie minie moe," Grandpa Ben tickled the rhyme on my palm. His thick Russian accent made me laugh.

.......

Hens and chicks bordered the path from the door of their house in Weirton, West Virginia to the pine-filled backyard where we'd tie yarn between tree trunks to create houses and worlds.

.......

In the kitchen, we'd fill diamond-cut glasses with cold milk or sparkling ginger ale to sip with weighty, warm slices of Grandma's pound cake. Other days, she made mandel bread, brownies or apple pies. After dinner, airy sour cream babkas like bakers hats were cut to reveal veins of cinnamon, sugar and nuts.

.......

"Jiminy Crickets!" Grandpa made this sound like the worst curse ever.

.......

He and Grandma owned a Mom & Pop where they worked 10-hour days, serving steel workers from all over Europe. Years later, we'd still get gifts from 'The Store': colorful patterned socks, jars of plums, bags of sugar, very wide ties.

.......

Grandpa had left school when he was 13 to escape serving 25 years in the Tsar's army. Hidden under straw in a cart with his little sister, they made their way to family in America. After he and Rose sold the store, they'd watch *Jeopardy* nightly, and we'd all guess along. Somehow, he got every question right.

Fashion terms I learned from them: Hose. My Garment. *Schmatta.* Comb Over.

.......

Eventually, they retired and moved nearby. On Sundays, they'd drive over and unload their hauls of all the supermarkets' specials. Grandpa read the paper; Grandma taught us *Gin Rummy, War* or *Spit;* occasionally, she rubbed my Dad's feet as he napped. Once, she and Ben argued over the price of ketchup until my mom began to slide out of her seat under the dinner table in despair.

.......

Grandpa's body still carried shrapnel from World War I. He never mentioned his Purple Heart. We discovered that years later in a drawer.

.......

When I asked how she felt, Rose replied, "With my fingers!" The last time I asked, she'd just spent five weeks in the hospital, being poked with needles and tubes. Her voice quavered, "Not so good."

.......

Despite all their arguing, Rose and Ben raised three children, loved eight grandchildren, and stayed married 50 years. When we had to tell her that he had just died during surgery, she began to sob and cried out from her own hospital bed, "I never said good-bye!"

.......

I took Rose with her walker to identify the muggers who'd pushed her and Ben down and robbed them in front of their senior apartment building, fracturing her pelvis, breaking his hip, and jogging away with $24 and a watch. With no window or partition between us, the guys in the line-up ten feet away, looked right back. She didn't recognize any of them.

Mimi Plevin-Foust

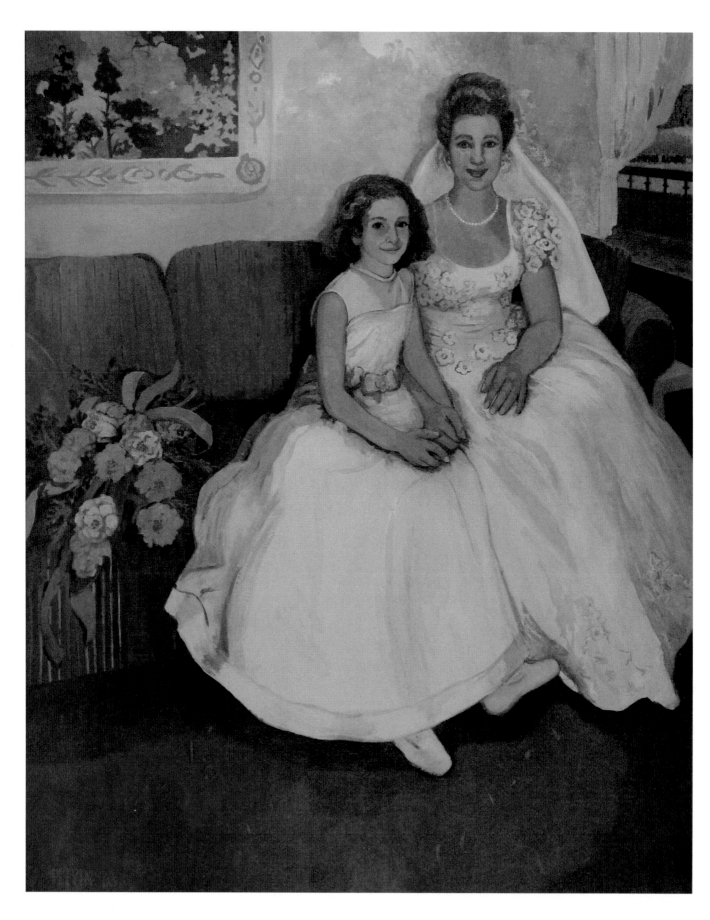

Before the Wedding (Sara and Hannah) 2003
Acrylic 60 x 48 inches

Sara and Hannah

"In Gloria's art, home is a conceptual rendering of a serene and orderly locus of family life, as it is meant to be. In her family portraits and even in her still lifes, there is, in the words of her close friend Ginny Cascarilla "a neat complexity" in image after image of stability and comforting family places. 'The Spanish Bride' (acrylic, 2003), a portrait of her daughter Sara dressed for her wedding, might have lapsed into sentimentality in the hands of a less insightful artist. In Gloria's depiction, the inclusion of her granddaughter Hannah, leaning against her aunt, tells a story of family bonds that bind women to women, generation by generation."

Louise Mooney
'Meet Me on the Veranda' program book
Cleveland Artists Foundation, August 2013

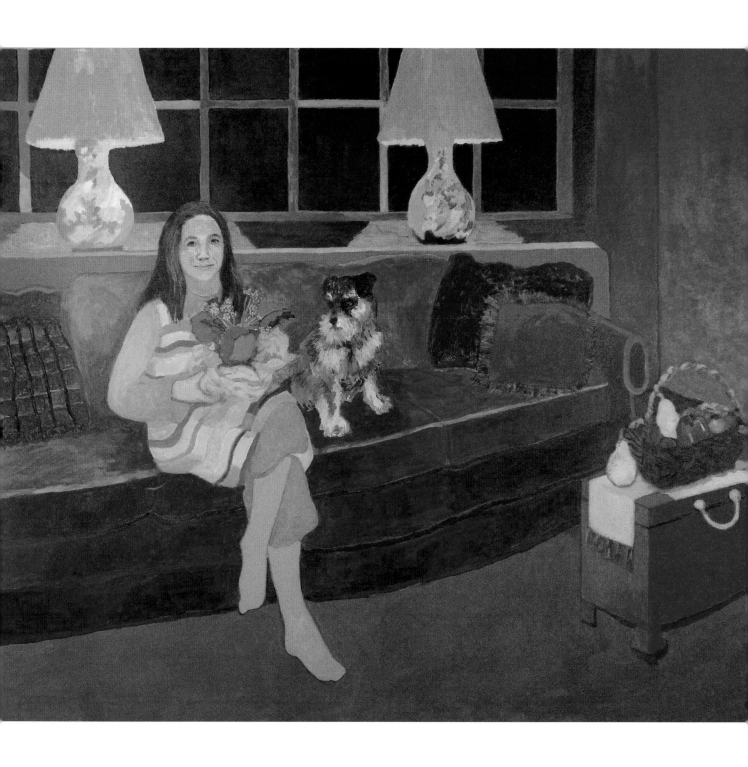

The Gift (Katy and Sammy) 2016
Acrylic 48 x 60 inches

Portrait of Katy and Sammy

Today I experienced a quiet but joyful feeling of accomplishment. Katy's portrait is my first and only evening interior. There have been problems to overcome, but in the final hours, each difficulty was resolved, and it all came to an exciting conclusion. The colors are subdued or brilliant; the design is fresh; and Katy looks directly at me with a lovely smile. With his gray, black and white schnauzer coat, Sammy sits right in the middle of the couch, looking inscrutable.

The final touch--the color of the cloth on the red chest in the foreground--is a gold pigment which actually glistens! It is fun; it is night; and the orange flowers Katy holds in the pot on her lap cast warm highlights on her young, pretty face. The entire composition is exquisite.

Gloria Plevin
From my diary, April 26, 2016

Did She See The Fireflies?

Mimi heard the urgency in my voice. "Is Katy at home?"

"She's here, Mom. Why?"

"Did she see the fireflies?"

It was dark outside on this warm June evening in Cleveland with a daytime temperature that had reached over 90°. Tiny points of lights flickered near the ground in the yard outside my apartment. Last year, there was so much rain that I don't recall seeing these tiny bugs.

My memory flashes back to summer evenings in Clarksburg, West Virginia when all the kids were allowed to play outside. We captured fireflies in jars with lids punched for air holes. The insects were eventually released or wings were plucked and woven into rings or bracelets. Any sense of wonder was not admitted.

One of my favorite poems "All Things Bright and Beautiful, All Things Great and Small, All Things Wise and Wonderful, the Lord God Made Them All," written by Cecil F. Alexander, still has resonance for me when I see the tiny flickering lights. What creative source designed and brought fireflies into the world?

Over the past few decades, I've traveled and seen great wonders.

In three countries—Japan, Costa Rica and Mexico— I've stood near the edge of volcanic craters, nearly overcome with the smell of sulfur. They reminded me that Hell and the Devil supposedly have that stench.

Near the edge of the abyss of the Grand Canyon, I looked on quietly with visitors from all over the world. As if in a holy place, we humans were tiny and overwhelmed by the beauty and power of Nature.

In Israel, I floated in the warm and salty water of the Dead Sea which makes swimmers completely buoyant. After a shower, my skin was soft, and I felt wonderful.

Mimi, who lives just around the corner, tells me that her Canadian house guests were enchanted with the fireflies in her yard. They had never seen fireflies in their region of Canada. This evening, I did not have to travel the world to appreciate its tiny wonders.

My granddaughter Katy agreed.

Gloria Plevin
June 28, 2016

Perfection

The great mystery of the world is perfection. We are all striving for it in some way, even my miniature schnauzer Sammy.

Yesterday, when I was not in the room, 12-year-old Sammy discovered the wonders in our open recycling basket at the top of the stairs. Although he's been scolded for getting into baskets, overcome with curiosity, Sammy selected and retrieved a piece of aluminum foil. (In his defense, we did keep his toys in another open basket a few feet away.)

When I returned to my apartment upstairs, there on the braided rug glistened a perfect circle of aluminum foil. Fourteen inches in diameter, it was composed of small chewed and molded wads of aluminum foil carefully laid equidistant with just a little space in between. If I were an art reviewer, I may have been tempted to write, "Pay attention, Collectors: Here is a modernist work of art by a new creator who makes unusual objects from found materials. The fact that the artist is a dog may be of interest."

Did I do the motherly thing and praise Sammy for his creation which, in retrospect, I consider astonishing? No, indeed; I bawled him out. "Bad boy!" I yelled. "Stay out of the basket! No basket! Bad Boy!" I cringe to think of my knee-jerk reaction. With not even a photo to prove what I'd seen, I threw Sammy's perfectly-arranged found art into the trash.

Gloria Plevin
September 8, 2015

Living on the Grounds

For 47 summers, my family took up residence in one of two homes in Chautauqua, New York. Our family of wife, husband, four kids, two cats and one large dog would spill out of two packed cars at our first little house in the Chautauqua Institution enclave a week before the opening of their ten-week season. We spent that week unpacking and settling in. No cleaning person came in to help with all the chores. This work belonged to me and the kids, and for those seven days, we never even looked at the lake shimmering just a block away.

After a weekend, Leon left us to our jobs and returned to his work as a lawyer in Cleveland. He and I believed chores were good for children's character development. Now that I'm over 80 and my family is grown with their own kids, I can declare that my husband and I were right.

For 18 years, we were totally engaged in life on the Chautauqua grounds. Art classes for Mom; Children's School for the two kids under six; camp, music, arts and crafts or theatre for the two older ones; plays, concerts, evening gatherings by the fountain with friends for the adults or entire family. Eventually, we outgrew the small house, and I really needed my own space for an art studio.

In the local paper, we found a listing for a retrofitted barn one mile down the road. The ad described a property good for a studio, art gallery and/or antique shop. By the time we looked at the place in midwinter, a hill of white snow blocked the front door. We climbed over the hill and jumped down onto the floor of the small porch. Inside, the building was dark brown with red trim on the sills. Since I love all things red, a better selling point could not have existed. Of course, we bought the place.

Gloria Plevin
June 11, 2018

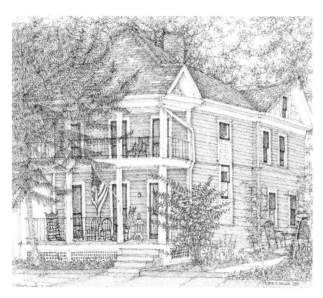

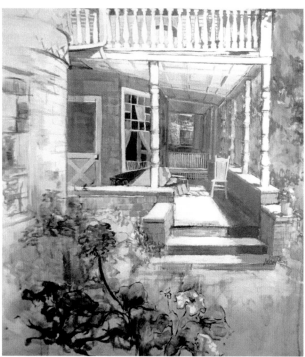

My 1973 watercolor painting of a porch in the colorful and closely situated houses of the historic section within the Chautauqua Institution is my only image of architecture. It was accepted into the highly competitive Butler Institute Midyear Show in Youngstown, Ohio in 1974.

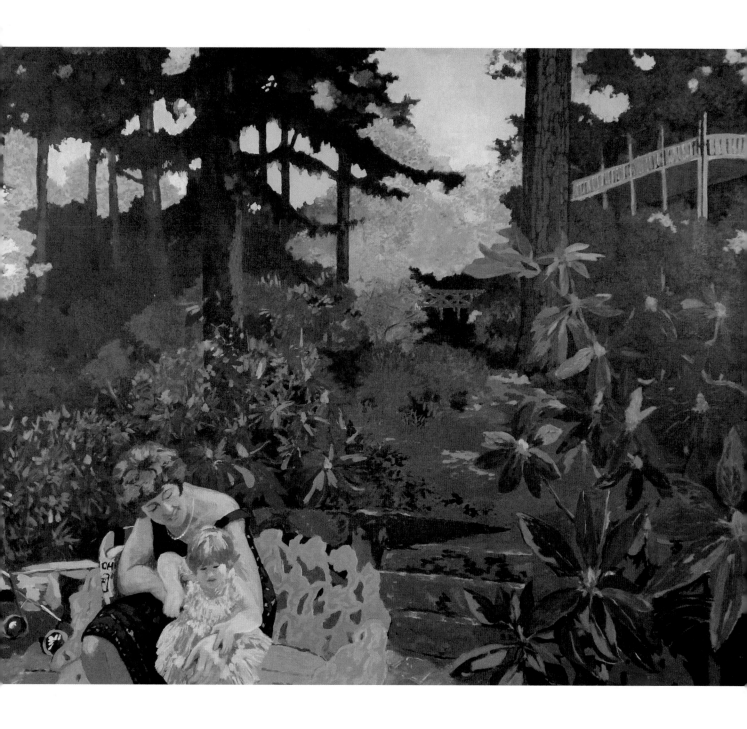

Plevin Chautauqua home, Art by Jane Nelson (top left) 1973
Pen and ink 9 x10 inches

Simpson Street Porches (bottom left) 1973
Watercolor 36 x 29 inches

Ann and Katy in the Glen (Chautauqua Institution) (right) 1993
Acrylic 20 x 26 inches

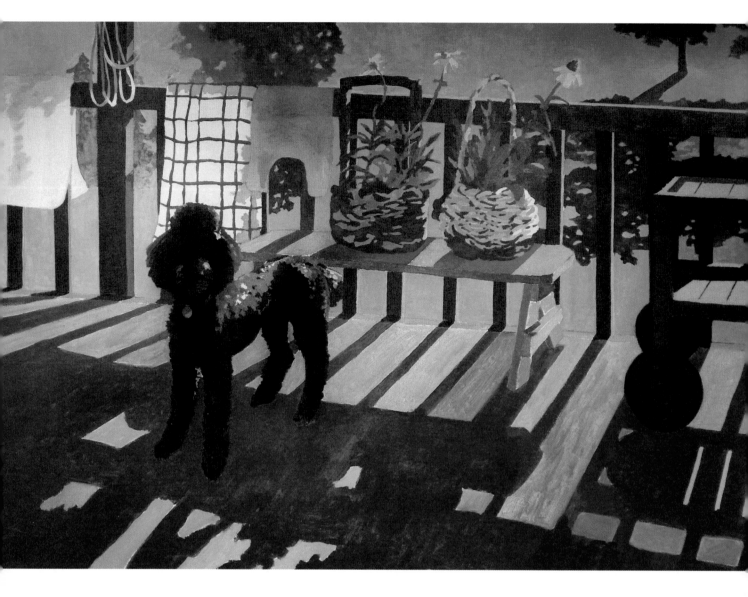

On the Porch with Charlie

The porches of my childhood in Clarksburg, West Virginia, circa 1938, were on the front of the houses. I was about four when I walked along Harrison Street visiting neighbors. On summer evenings, the heat was eased by woven palm fans and homemade lemonade. I knew everyone on the short street, and sometimes I was invited onto a porch for a rocking chair visit and a little chat.

As I grew, suburban houses were no longer built with front porches. The guy who wished to be in front of his house brought out a folding chair and sat on his cement driveway, possibly with a beer in hand.

On the Porch with Charlie 2011
Acrylic diptych 48 x 148 inches

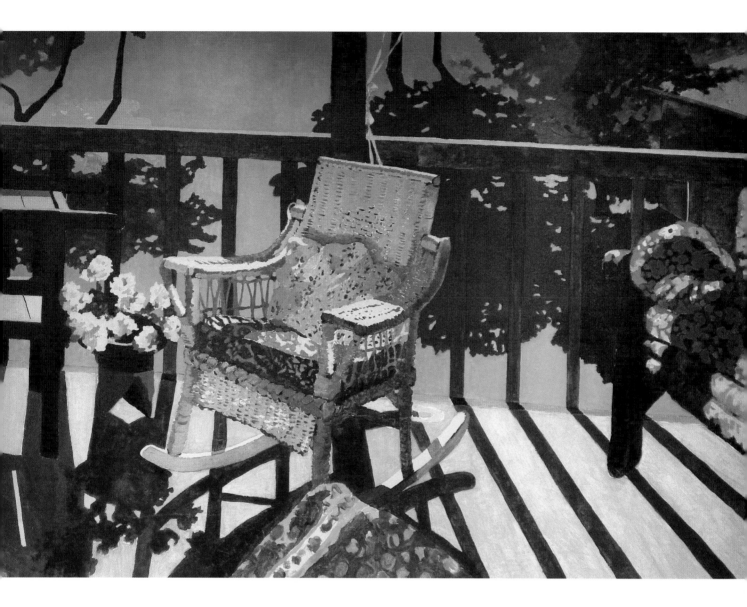

The porch featured in my large diptych *On the Porch with Charlie* was an addition to my retrofitted barn/home in Chautauqua County and should probably be called a deck since it's on the second floor behind the building. A roof partially shades half the deck; the other half is open to sun or rain. At various times, my family has shared the space with nesting robins and, one memorable summer, a brood of barn swallows.

I created *On the Porch with Charlie* because I was interested in the way the sun and porch railing striped shadows across the floor. I also included items from our life inside: a towel and t-shirt hung to dry in the sun, soft cushions beckoning on wicker chairs,

plants growing, and the main character—our elegant standard poodle Charlie—standing at alert. I returned to the porch as a motif in the monoprint *Aaron and Charlie,* the pastels *Black-eyed Susans* and *Pond, Cottage and Cottonwoods,* and many other pictures.

Wherever my family is living, coming home to Chautauqua has always meant a lot of people ingathering onto the porch. We are drawn there to chat, eat, read or relax. But, sometimes, the early riser enjoys the chance to sit outside alone in a rocker sipping the morning's first cup of coffee and watching birds at the feeder in the yard below.

Gloria Plevin
July 11, 2011

A Table, a Place, and Loved Ones
(Sara and Alexi in the Kitchen)

Between 1985 and 2005, I completed three paintings of loved ones seated at tables, combining my interest in still lifes with a lifelong fascination with people. The paintings are *Sara and Alexi in the Kitchen, Hannah at Passover,* and *The Scrabble Game.* The first painting takes place in our old house on Shaker Boulevard; the second in my current apartment, and the third on the deck of our converted barn in Chautauqua.

In the first painting *Sara and Alexi in the Kitchen,* my daughter Sara relaxes at the breakfast room table with her dear Siberian husky Alexi near her feet. Sara is pushed way back in the picture in the manner of Vermeer. Autumn morning light brightens the room.

On a wooden table in the foreground sits a vivid but less bright still life of acorn squash, onions, and a hand-painted tureen. An electric can-opener of the period sits on the right. The kitchen's cheerful blues and yellows and painted ceramic dishes were chosen to complement our French Normandy-style house that contained the scene.

Gloria Plevin
February 4, 2019

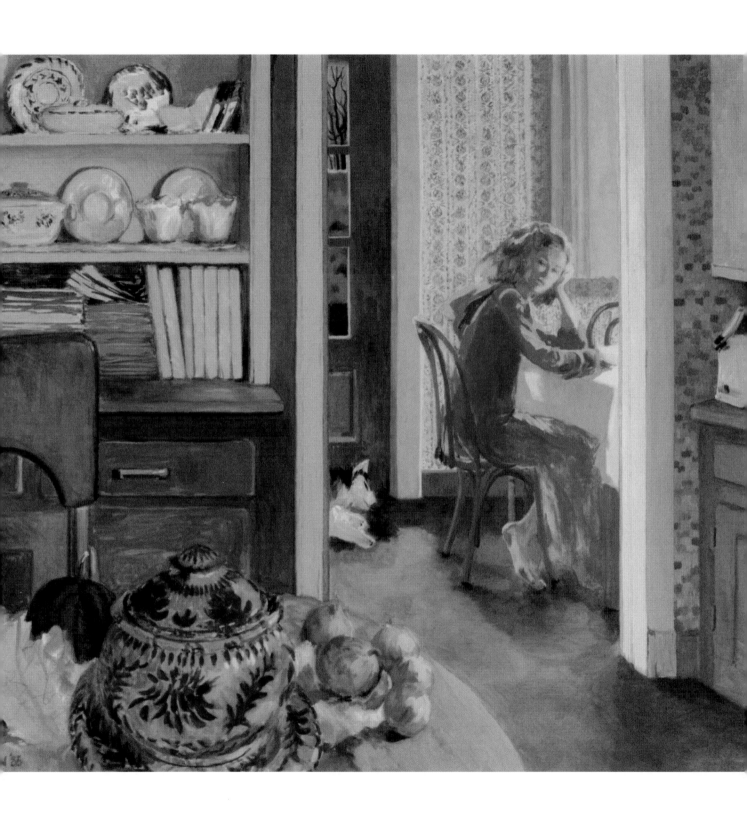

Sara and Alexi in the Kitchen 1985
Oil 36 x 42 inches

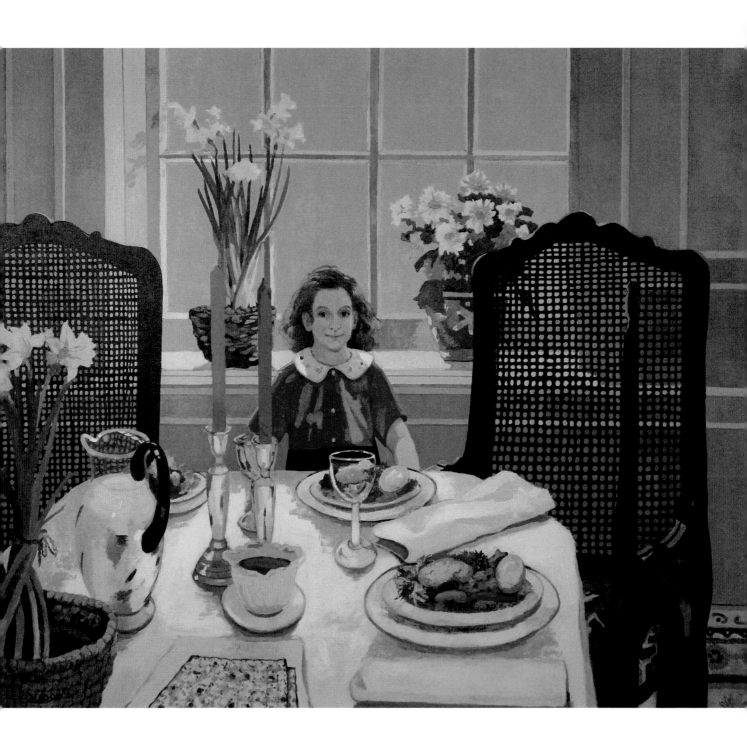

Hannah at Passover (above) 2000
Acrylic 48 x 60 inches

Hannah at Passover sketch (right) 2000
Pen and ink 8.5 x 11 inches

Hannah at Passover

It is my good fortune that the painting *Hannah at Passover* will be part of the exhibit "A Century of Portraiture" at the Cleveland Artists Foundation during March and April. The colors throughout the picture speak of Spring, including bright yellow daffodils, green vegetables on plates, and pearly eggs. They all remind me of new growth and hope.

In many ways, the painting is like a play, and all the elements are like characters contributing to its totality. Hannah, my granddaughter, has just stopped running for a moment and with puckish expression looks expectantly at the white-clothed table which has been formally arrayed for the feast to come. Her red dress echoes the color of the crimson horseradish in the white, fluted bowl. Silver candlesticks, once used every Friday by my mother, reflect all the colors around them. Square baked matzos and woven brown baskets add texture. Through sparkling clean windows, warm early evening light casts soft shadows on the woodwork and tablecloth and filters through the glass in the shapely pitcher. Tall, formal caned chairs both define her small size and represent the adult guardians who will soon join her at the table.

Completed in 2000, *Hannah at Passover* has precedents in works where family members and even a begging dog are seated around a table scattered with the remains of a meal. Such scenes were used by the French artists Edouard Vuillard (*The Vuillard Family at Lunch* painted in 1896) and Pierre Bonnard (*La*

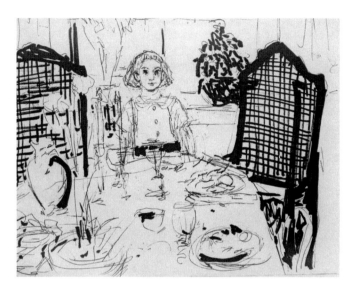

Table [1925] and *The Luncheon* [1932]). They, in turn, influenced the American painter and art critic Fairfield Porter. One of Porter's best-known paintings of his baby daughter sitting in a highchair, *Lizzie at the Table* (1958), was shown at the Cleveland Museum of Art and reverberated in my mind for years. I believe it sparked the recognition of a great moment to capture in paint when Hannah paused by the table before the family seder.

Gloria Plevin
February 19, 2002

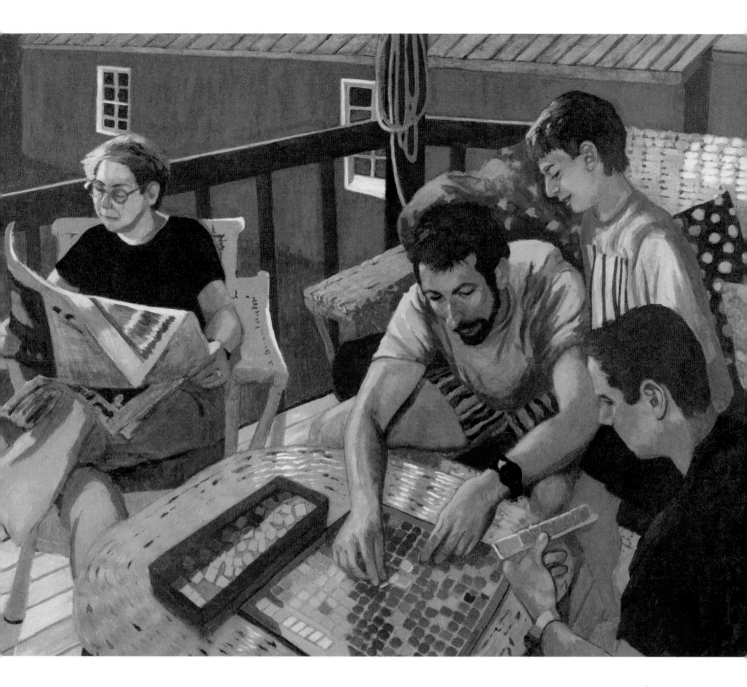

The Scrabble Game

When I saw a group of my family members playing Scrabble on the porch for the first time, I ran for my camera and stood on a little stool in order to get a slight angle of looking down on them. My grandson Aaron observing his father play was my attraction for the painting to be made, but the notion of people engaged around a table was the theme that resonated in my art history-saturated brain.

The Scrabble Game (above) 2005
Acrylic 20 x 48 inches

The Scrabble Game (right) 2004
Monoprint 17.5 x 23 inches

All painting is difficult. This composition seemed especially challenging: the concentration of all of the males playing the game and my sister-in-law Marilyn absorbed in reading the paper so that all eyes are lowered. The extreme angle of my son-in-law Sandy's body and his long arms and hands reaching for the scrabble tiles, and so on. So as happens with many of the large canvases, I did a pastel sketch to warm up to the problem, and a monoprint and its ghost to try out some colors. I show them all together as a little didactic event where the viewer can gain insight into the artist's creative thinking and also find that each kind of medium elicits a different reaction.

Gloria Plevin
May 19, 2018

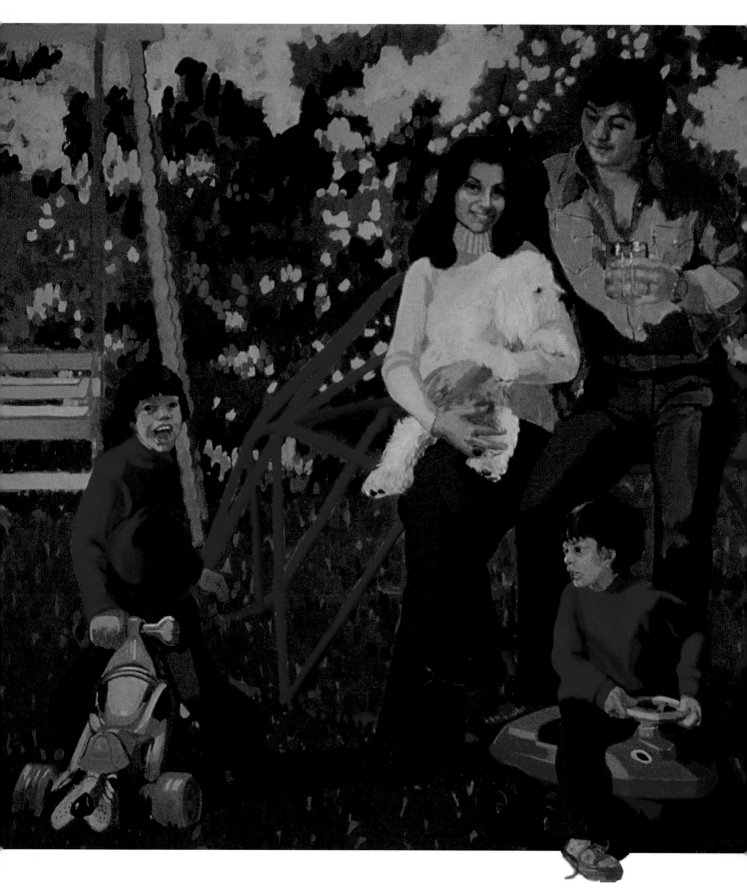

The Dickersons were good friends who also collected my art. It was a challenge to paint the whole family including two lively young sons and a bijon frisée puppy. Their blue jeans and geodesic dome jungle gym (a structure recently popularized by Buckminster Fuller) reveal their modern, informal lifestyle.

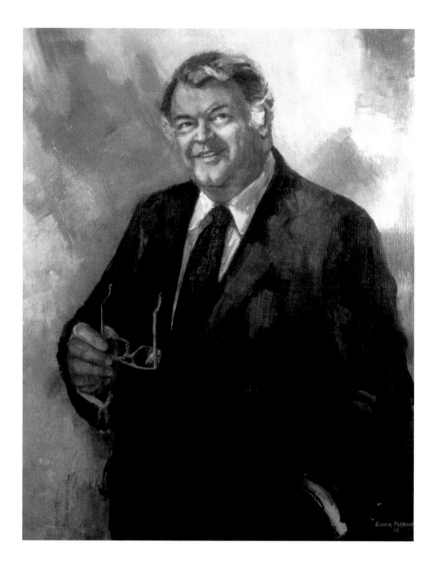

Painting Portraits

At the time I was commissioned to paint Norman Shibley, he was a highly regarded Cleveland attorney, past president of the Ohio Academy of Trial Lawyers, and friend of my husband Leon. I once saw him as he waited to give a public speech, holding his glasses delicately in his hand: I decided to paint him in that pose.

"Isn't a portrait the most difficult kind of painting to do?" I've been asked. It is difficult, but it would be presumptuous to say 'the most difficult'.

A portrait serves a purpose. Its function is to record the likeness of a person. Therefore, the artist has an obligation to paint a 'reasonable' likeness.

Beyond that, a portrait should reveal some aspects of character. Life has happened to this person—joy, pain, sorrow, time passing—all leave their mark. The portrait speaks about the artist as well as the person portrayed.

I once had the distinct pleasure of dancing with Norm who had perfect timing, perhaps because he was also a musician. I hope my portrait conveys his combination of dignity and delight in life's pleasures.

Maralee and Richard and the Pepsi Generation (left) 1976
Acrylic 60 x 60 inches

Norman Shibley (above) 1974
Oil 48 x 36 inches

Gloria Plevin
November 15, 2018

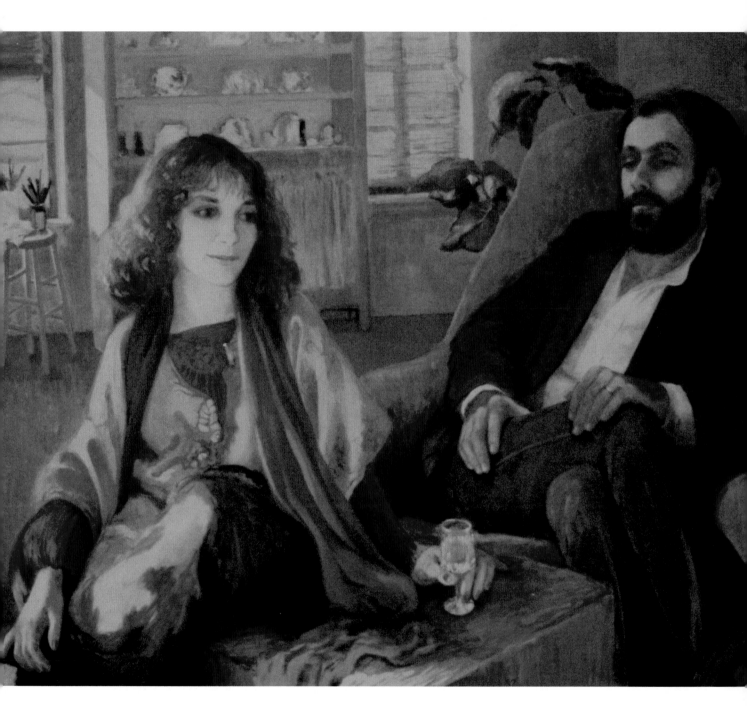

My smart, young friends Mirijana and Branislav Ugrinov moved to Cleveland from Yugoslavia. She was an exquisite beauty and artist; he worked in architectural design. Worldly and wise, they brought the inventive Paulo Soleri to town and introduced local artists to Italian design and other new styles. They fascinated me and greatly expanded my knowledge of the world.

Mirjanna and Branislov Ugrinov 1985
Oil 34 x 46 inches

At the Woodtrader 2017
Acrylic 36 x 29 inches

Owner of the popular frame shop The Woodtrader
since 1975, Sara Kraber was a positive influence
for me at a time when women looked to have their
own careers.

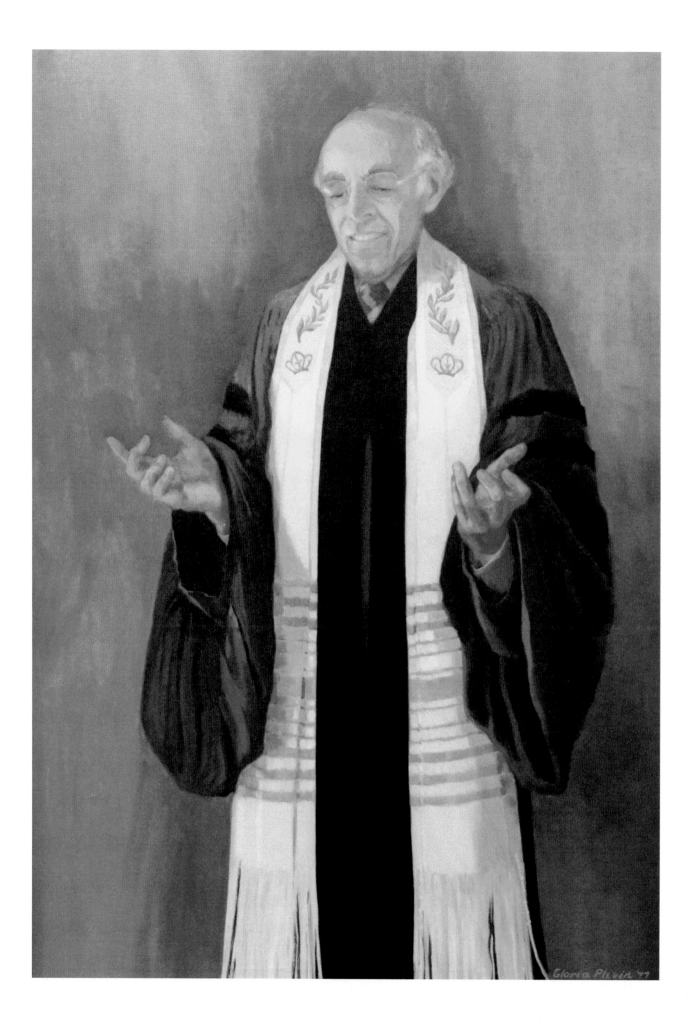

Gloria Plevin '77

Painting Rabbi Green

In 1978, my husband Leon and I had been members of Temple Emanu El for almost ten years. I truly loved and admired their inspiring founder and senior rabbi Alan Green. Whenever he stood on the bema sharing a sermon or giving his blessing, he seemed to radiate spirituality, kindness and joy.

So when the temple's board commissioned me to paint a portrait to celebrate his elevation to Founding Rabbi after 30 years of service, I was both honored and intimidated: Could I create a portrait that would do him justice?

I arranged for Rabbi Green to come to my home studio to pose wearing his black robe with the three black doctoral bands on its large, wide sleeves and his long white tallis. Because we saw him most often up on the bema in front of us, I decided to paint him as if he was standing higher than the viewer, looking down as if to bless a child. Since we all looked up to him as our spiritual leader, the pose seemed apt.

To get the right angle, he offered to stand on a chair as I sketched and then painted even though he was almost 70. Whenever Rabbi Green came over for the next few weeks, I helped him step up and down from the chair. Teasing, he said I treated him like my dog. "Why?" I asked, embarrassed. "Because," he said, "you say 'Up, Rabbi! Down, Rabbi!'"

I was impressed that Rabbi Green could stand for twenty minutes at a time, hands extended as if giving a blessing, without moving or even trembling. He explained that he was calm because he didn't drink coffee or anything that might upset his nerves. True to form, he proved to be not only steady but also delightful, amusing and wise.

It's not easy to paint a good portrait, and it's especially hard to paint people's hands. So when the time came to paint Rabbi Green's hands which were held out in blessing, I silently prayed to God for help in rendering a hand position I had never tried to paint before. As each finger and thumb came into being correctly, I felt relieved, grateful and amazed.

On the evening of the celebration after the painting was presented to the rabbi and the entire congregation, I was invited to hold and walk around the sanctuary with the Torah. I had never before been given this honor, but I carried the Torah as best as I could and was thrilled to do so. Later, a friend said I carried the Torah like a baby.

Soon after, Rabbi Green gave a sermon with a theme that has been a watchword in my life, especially since I have little patience with the list of sins in the Jewish holiday prayer book. For his sermon, Rabbi Green chose the sin of Joylessness.

I am very aware of difficulties and sadness in my life and others — we all have our share — but Rabbi Green's caution has been everlastingly important to me. And so I am sharing it with you, dear Reader: Remember the sin of Joylessness and find some joy to celebrate in your life this year and every day.

Gloria Plevin
September 17, 2018

Rabbi Alan Singer Green (1907–1989) (left)
1978 Acrylic 72 x 48 inches

February 1982
Watercolor 18 x 24 inches

SUR LA TABLE

Painting Still Lifes

At first, as an artist, if you stop painting portraits, you can paint still lifes. They begin in the kitchen— no, they begin in a garden— if not your own, then the gardens of farmers at markets in Chautauqua or Shaker Square. And in the market you discover a big knobby cauliflower with gigantic leaves that seem strange and unfamiliar. And would that enormous cauliflower look good on a table with some kitchen paraphernalia tucked amongst its scary greenery?

With that cauliflower, I became hooked on still lifes. Surprisingly, all the fruits and vegetables and crockery and other items were a lot of fun to paint. They didn't mind if the picture did not look just like them (unlike the humans whose facial expressions and character were so difficult to paint exactly right).

And there were these artists like Van Gogh and Vuillard, Cezanne, Monet and Bonnard and all those Japanese printmakers, who lit my way. So that, for ten years, I was able to grow as an artist who was excited, challenged, and content with arranging each still life as a 'visual walkabout' placed in a unique setting that I found both beautiful and intriguing.

Gloria Plevin
April 25, 2018

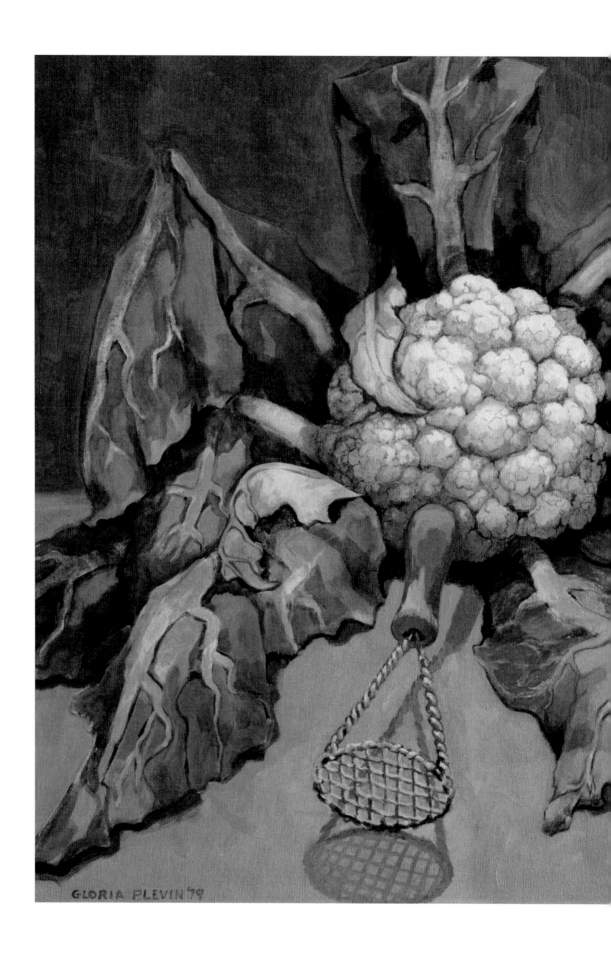
GLORIA PLEVIN '79

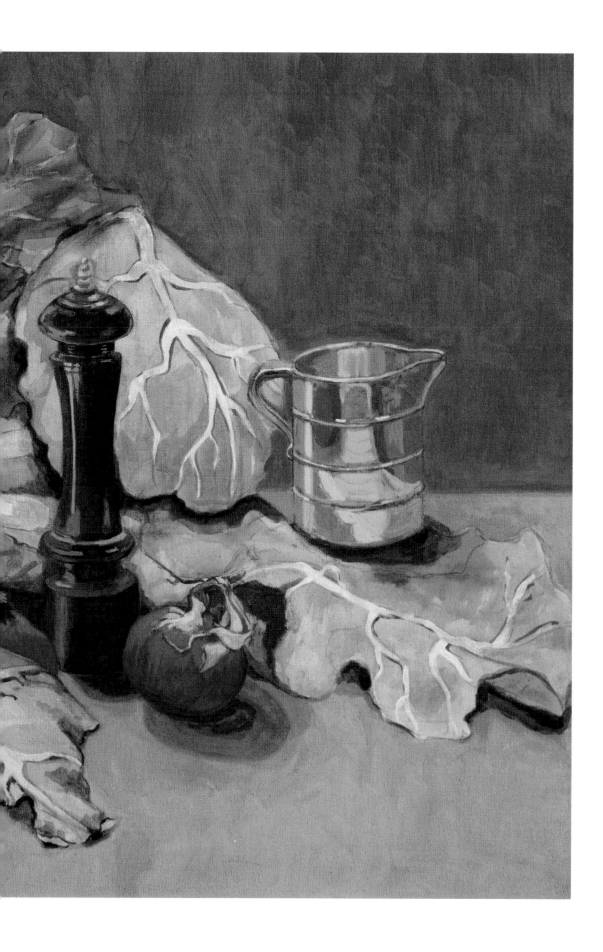

Cauliflower and Kitchen Items 1979
Watercolor 24 x 36 inches

Squash and White Napkin (above) 1987
Watercolor 18 x 20 inches

Paper Whites (right) 1986
Watercolor 21.25 x 15.75 inches

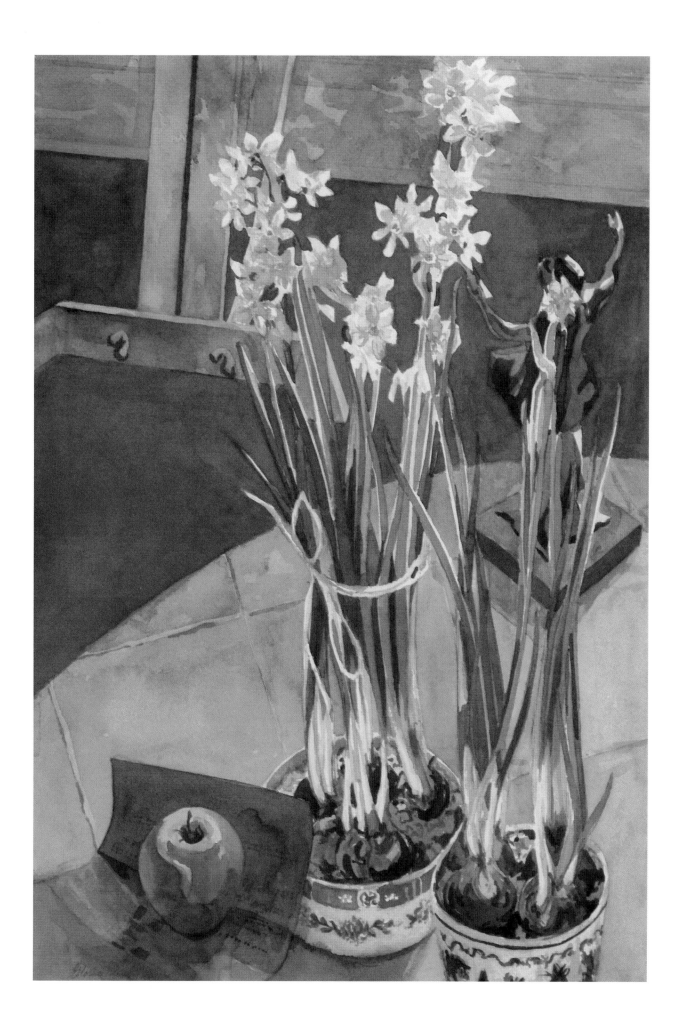

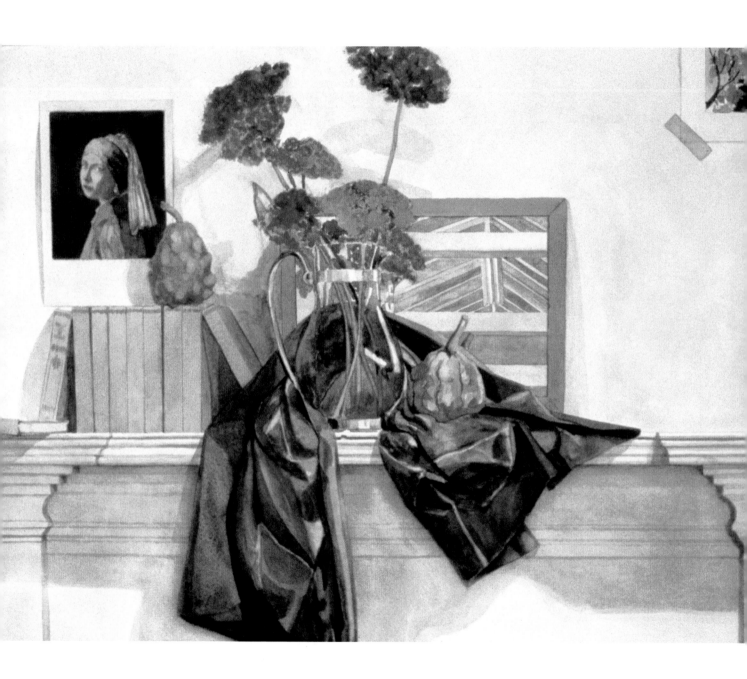

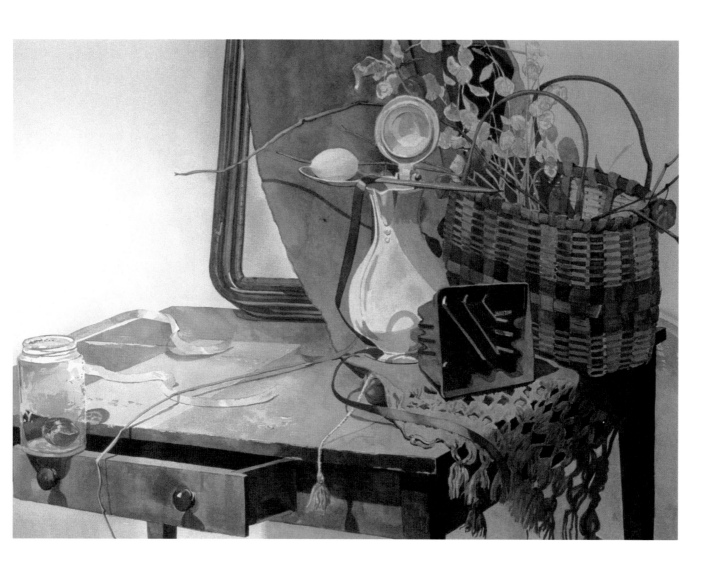

In Praise of Northern Light (left) 1987
Watercolor 21 x 28.5 inches

The Fragility of Freedom and Creativity (above) 1988
Painted in Honor of Israel's 40th Birthday
Watercolor 34 x 25 inches

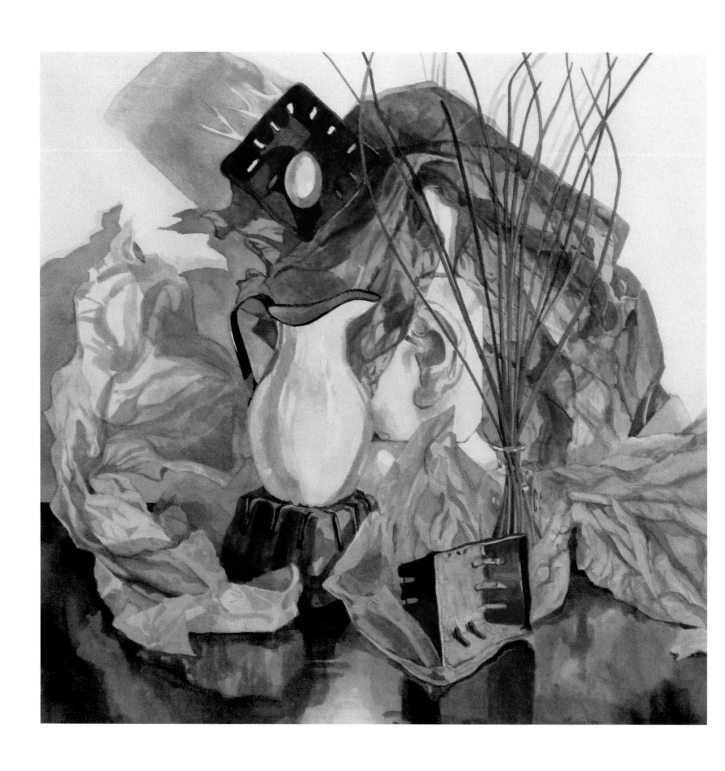

The Better to Hear You (above) 1991
Watercolor 24.5 x 25.5 inches

Luneria (right) 1986
Watercolor 26 x 20 inches

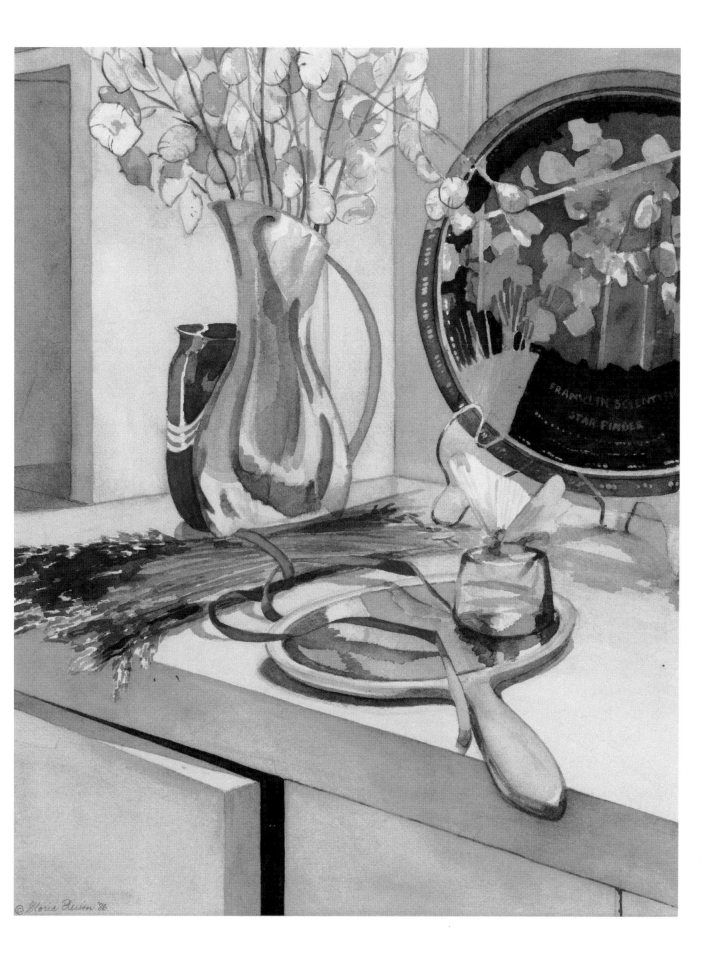

FRANKLIN SCIENTIFIC

STAR FINDER

© Gloria Rewin '86

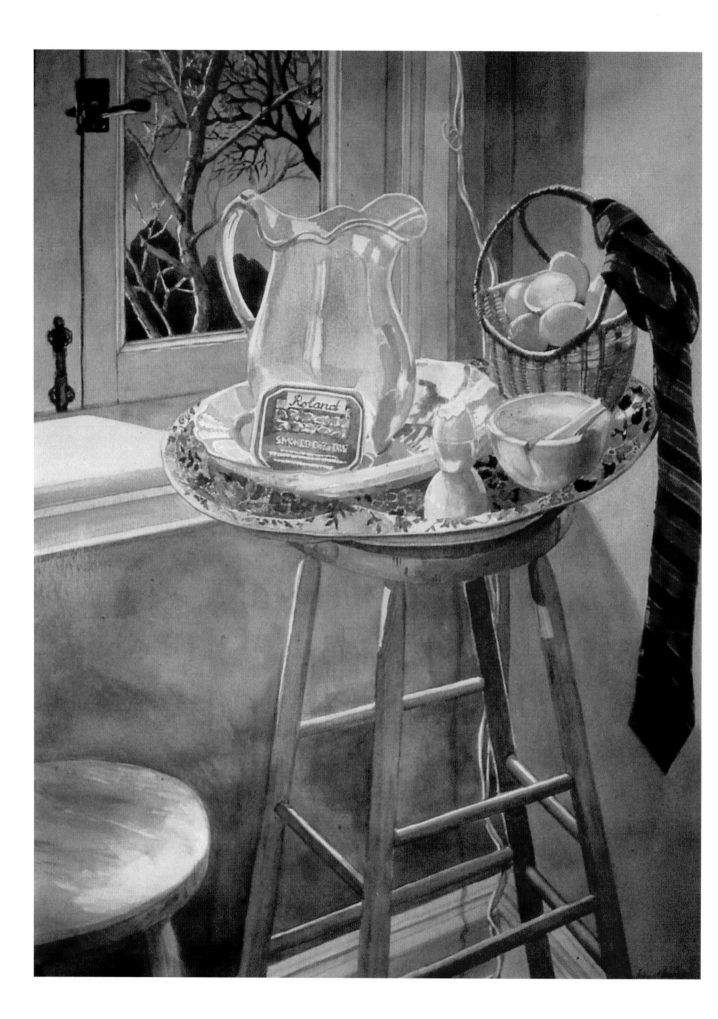

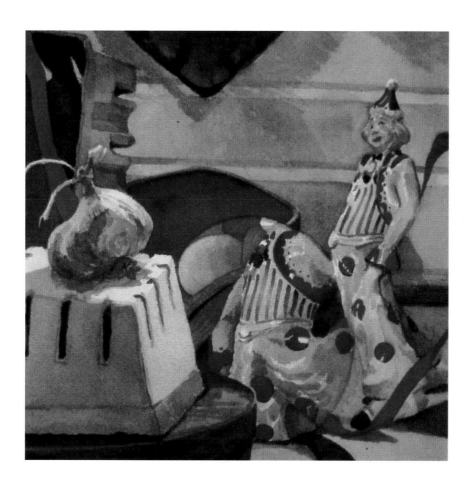

Two Clowns

Two clowns came home from Israel with Leon and me. We had just visited Leon's Aunt Matilda in Tel Aviv where she lived with her husband Mendel and daughter Leah. The couple had married in Estonia after learning that both their spouses and Mendel's children had been killed during World War II. In 1959, they emigrated to Israel with Leah, their only child, to start a new life of freedom together.

Our visit brought us all much joy. As we parted, the now grown and married Leah gave us two ceramic clowns as a special gift. The family had brought the clowns from Europe when they moved, and now these porcelains would travel with us to their third continent, America, reminding us of life's fragility and its persistence.

Gloria Plevin
March 2019

Eggs in the Afternoon (left) 1988
Watercolor 29 x 21 inches

In the Limelight (right) 1991
Watercolor 9.75 x 10 inches

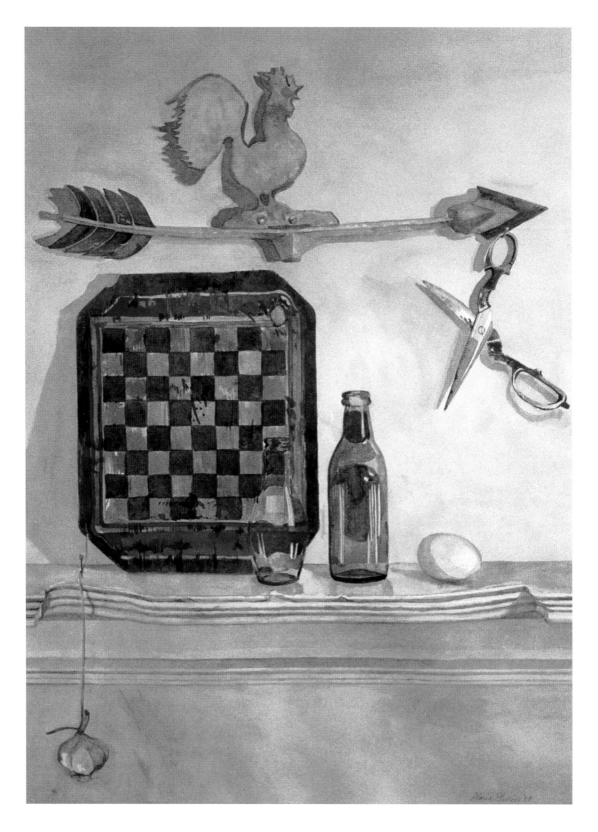

What Makes the Cock Crow?

I've titled my painting *What Makes the Cock Crow?* It's an allegory about the male of the species: The checkerboard shows love of games and winning. The arrow stands for weapons and skill. The scissors evoke tools and industry, their sharpness suggesting fighting and war. The egg symbolizes sex and procreation; the garlic, love of food; and the beer bottles, fondness for drink.

What Makes the Cock Crow? (left) 1989
Watercolor 28.75 x 21 inches

Still Life in New York City (above) 2001
Acrylic 21.5 x 31.5 inches

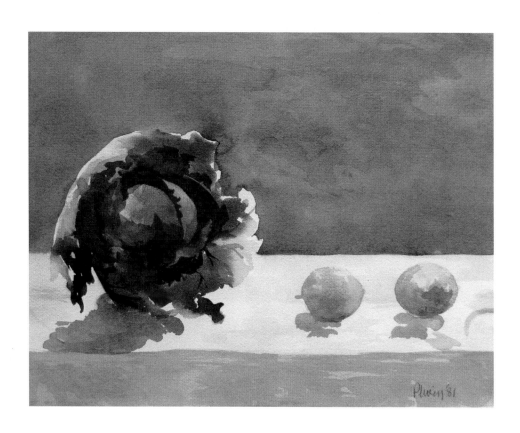

Cabbage and Limes (above) 1981
Watercolor 10 x 14 inches

Purple Box, Eggs and Squash (right) 1988
Watercolor 29 x 21 inches

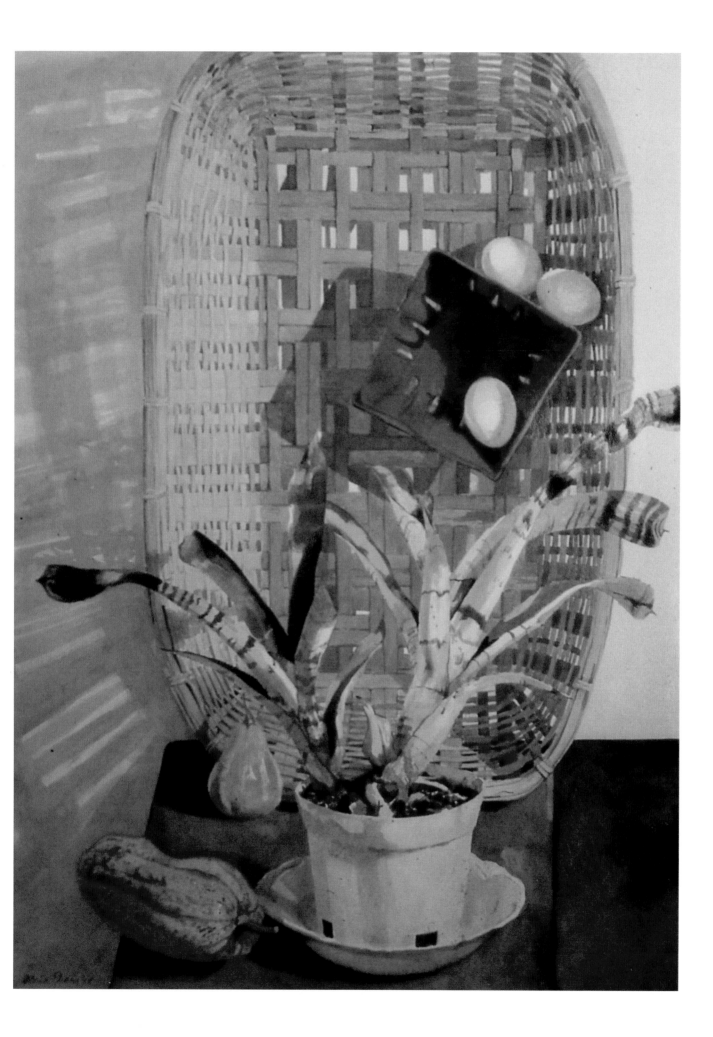

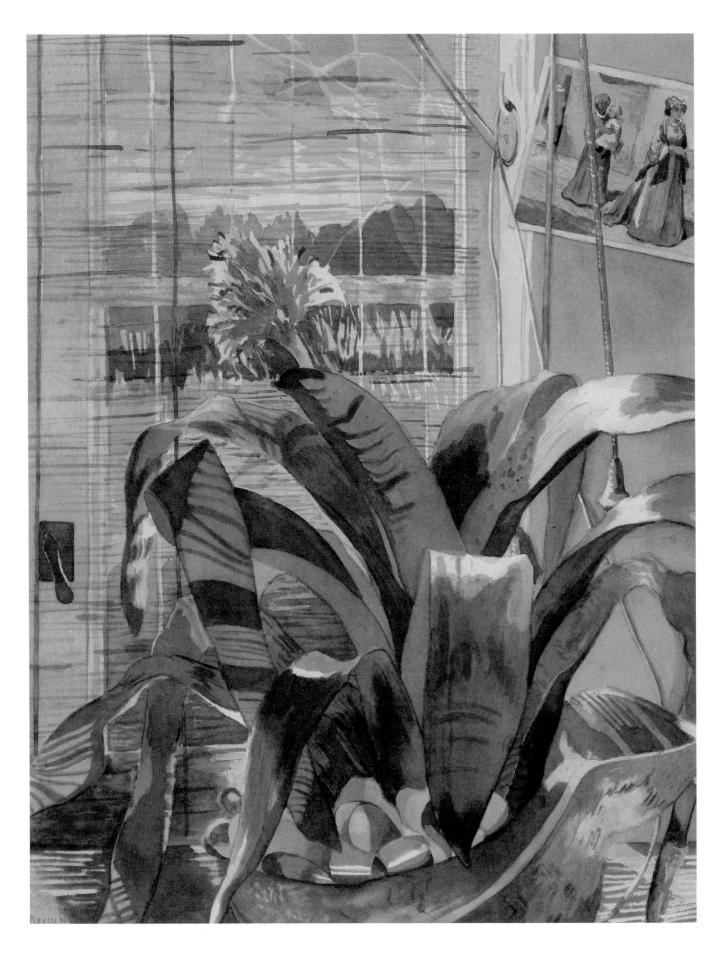

Island Flower 1987
Watercolor 22 x 17.5 inches

Island Flower

When our family returned to Cleveland from a week-long holiday in Martinique, we found ourselves surrounded again by ice and snow. Except for our youngest daughter Sara, our children who had traveled with us (Andrew, Ann, Mimi and her husband Bill) were dispersed around the country. So I was delighted when the gift of a large tropical plant arrived from the florist a few days later. It was a bromeliad with an exquisite pink flower. I decided to paint it staged in an island scenario while our trip's sunshine and greenery were fresh in my mind.

We had decided to visit Martinique's family-friendly Club Med partly because I've always been fascinated by everything French. We especially enjoyed their New Year's Eve celebration that featured small dramatic performances all around us, fancy appetizers, and beverages of every type, color and flavor. Singing and dancing to please all ages kept my kids moving far into the night.

None of this prepared me for our day trip the next morning.

With a Club Med bus and tour guide, we traveled around the island to the town of Saint-Pierre. Founded beside a lovely bay in 1635, Saint-Pierre had been Martinique's economic and cultural center—the 'Little Paris of the West Indies.' Yet what we saw as we walked down its streets was a nearly lifeless place—just small ordinary buildings or gray wooden homes with few of the flowers or amenities one might see in a normal French town. Our guide proceeded to tell us the city's tragic story.

Saint-Pierre was destroyed in 1902 when Mount Pelée—a large volcano four miles away— suddenly exploded, unleashing two deadly-hot clouds of volcanic gases, superheated steam, and dust that sped out over an eight-mile area. Within three minutes, the first, ground-hugging cloud charred most of Saint-Pierre, killing almost all of its 30,000 residents and visitors.

The only survivors were believed to be a prisoner locked in an underground jail cell who later toured the world with the Barnum & Bailey Circus, another man who lived near the city's edge, and a ten-year-old girl who had rowed to shelter in a cave.

Today, Saint-Pierre is the capital of Martinique's Caribbean North District. Though never restored to its past splendor, it's been designated a 'City of Art and History' with some shops, a historic theater, and a Volcanological Museum.

For my watercolor, I placed the bromeliad on a table before a door with windows that look out at stylized trees. A bamboo shade casts striped shadows over the plant's strappy leaves. And, as a small salute to the lost denizens of Saint-Pierre, I placed a postcard I'd brought from Martinique in the upper right corner—the image of an elegantly dressed woman out for a morning stroll with her baby and servant.

Gloria Plevin

P.S. The eruption information is from Wikipedia. My vacation adventure is true.

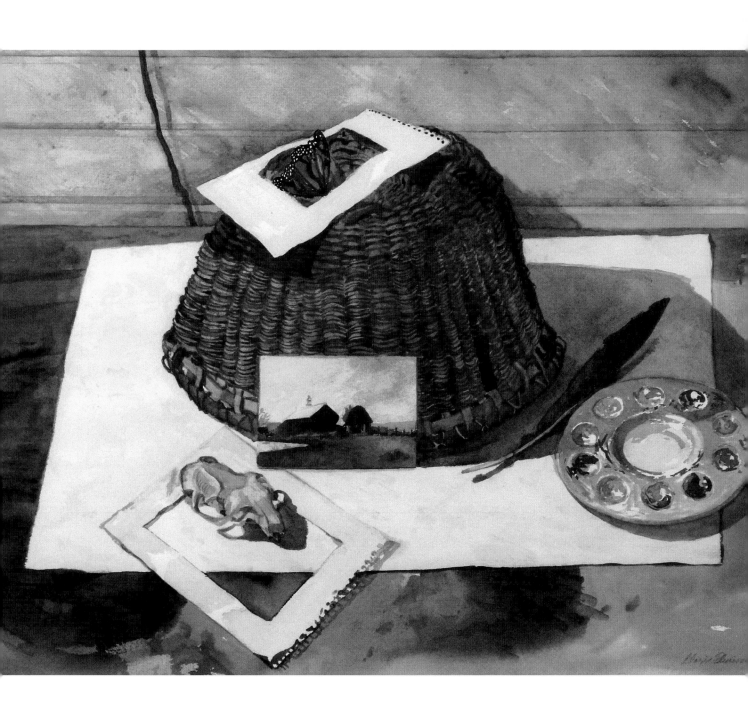

Remnants of Former Greatness

Sunny, 50 degrees. Today I completed the second painting using the old Indian basket.

The following items are in the picture: old Indian basket, monarch butterfly, black feather of a Canadian goose or crow, paint palette, skull of a small animal, (possibly a muskrat from our pond), photograph of barns near the gallery at Chautauqua, viewfinders made of paper, large sheet of white paper.

I've been searching for a title, and when Sara came home, she suggested the word 'remnants.' I'll call it "Remnants of Former Greatness."

Gloria Plevin
From my diary
November 26, 1990

Remnants of Former Greatness (left) 1990
Watercolor 20.5 x 28 inches

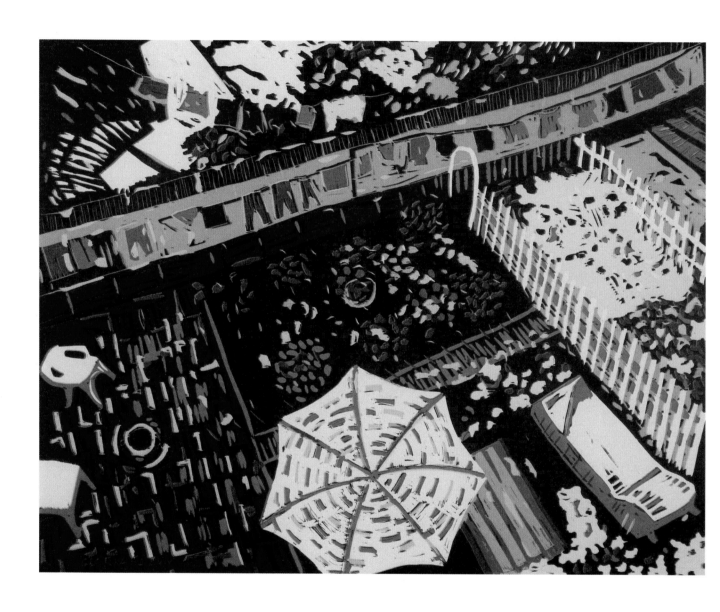

MAKING PRINTS

Zygote Press

I had learned nearly every print process while taking classes at the Cleveland Institute of Art but could no longer work with acids and solvents due to a bronchial weakness. Yet, I was brimming with ideas for more prints. After admiring some etchings by Lawrence Channing, he told me about Zygote Press, a local artist workshop promoting contemporary fine-art printing. Channing suggested that I call artist Bellamy Printz, one of Zygote's four founders.

Bellamy and I began a three-year working relationship and lasting friendship: She helped me develop etching plates while other artists generously helped with editioning. My work with Bellamy included a series of colorful etchings of Chautauqua in winter now on display at Cleveland Marshall Law School. Over ten years' time, I've had the great fortune to work with several of Zygote's talented printmakers, allowing me access to another medium that's enabled me to grow as an artist.

I created my print *Backyards Chicago* with the help of a second Zygote co-founder, Kelly Novak. The third floor deck of my daughter Sara's Chicago home, offered a lively view of fenced-in backyards with gardens, summer furniture, and wash flapping on a line. I created a pastel painting of that image, but it still hung in my imagination.

Kelly helped me step-by-step through a reduction linoleum block process which took eight weeks to complete. Adding each color required carving the large linoleum block with a sharp tool, beginning with white, then cutting away, one color at a time, until the grand finale—black. I carved the block and Kelly printed. Each color needed a week to dry. Kelly had the ability to plan ahead and was a consummate craftsman, essentials in producing a reduction print. Together, we created an edition of 15 beautiful prints that have been purchased by many collectors.

In 2008, I had a solo exhibit at Zygote which had moved to a building near my studio. By that time, I had completed a large and varied group of etchings, monoprints, and reduction linoleum block prints with the help of Zygote's gifted artisans. The show was scheduled to open less than two weeks after my husband of 52 years had passed away at age 76. That evening, surrounded by a gallery full of prints and packed with friends and family, I described my dear Leon as "the wind beneath my sails."

Gloria Plevin

Backyards Chicago (left) 2002
Reduction linoleum block print 18.5 x 23.5 inches

A New Kind of Parade

On a pleasant summer evening in Chicago, I went to see *Paradise Blue,* a new play by the brilliant writer Dominique Morisseau, with my youngest daughter Sara, her husband Jorge, and my middle daughter Ann. The performance had ended with an unexpected Bang!, leaving us shocked and slightly dazed as we left the theater. Jorge found the car and edged us into traffic. Within a couple of blocks, he stopped at the first light.

Although the light turned, we were stuck in place: A parade approached. It was 10:30 p.m.! A city block full of bicycles with all bells ringing headed our way, and the riders were totally naked! The first block of riders were lively; the next block of riders noisy and happy, and yet another block just as exuberant. The colorful extravaganza included fancy hats, scarves, and handmade jewelry hung around young, middle-aged, and even old necks. The cops blowing whistles along the sides, were fully dressed and mostly smiling.

We watched hundreds of delighted, outrageous nudies cycle by. The women were blazingly happy, exposing breasts large or small, as were the guys, though their penises were less obvious and tucked in a bit. All this was a new experience for me. I'd been a naive young girl and confess to being a prudish old lady.

We were stopped three times at various intersections for ten or more minutes to allow the same parade to go by. Tired, bored, and getting cranky, I longed for the soft pillow in my little weekend apartment. As an artist, I've sketched many naked men and women. I've admired nude images created by the great masters, particularly Michelangelo's statue of David. Nevertheless, I found the endless bare bodies cycling by en masse less than appealing.

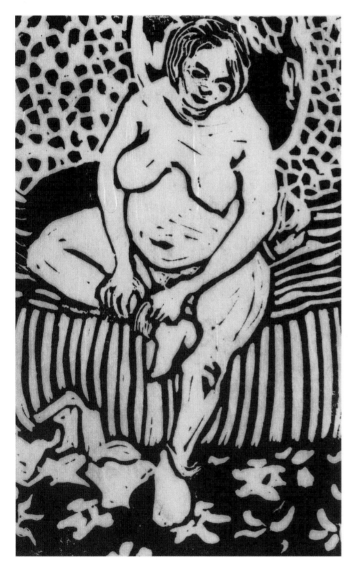

Later, I learned from my well-traveled granddaughter, Hannah, that nude parades are popular in many cities, raising money for charity with many style variations. To conclude, I admit that I had an amazing, memorable experience, but, truly, one "nudey" parade in my life is enough.

Gloria Plevin
August 5, 2017

Nude Pulling on Her Socks 1986
Linoleum Block Print 8 x 5 inches

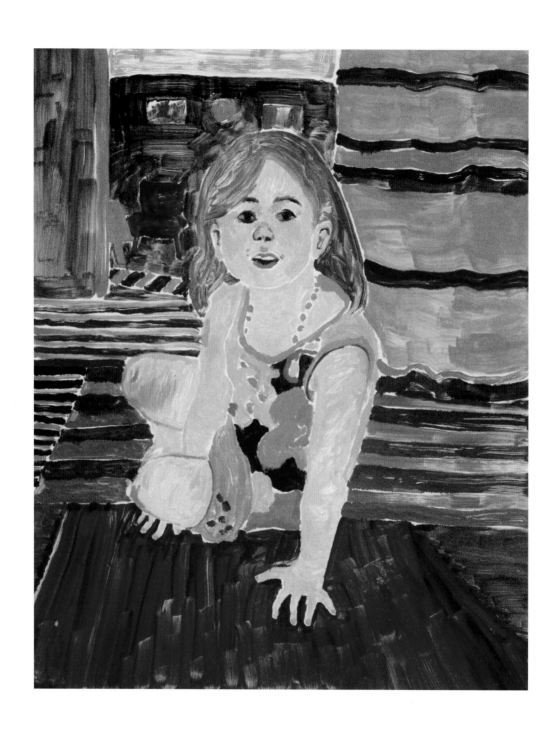

Athena in Greece 2008
Monoprint 16 x 14 inches

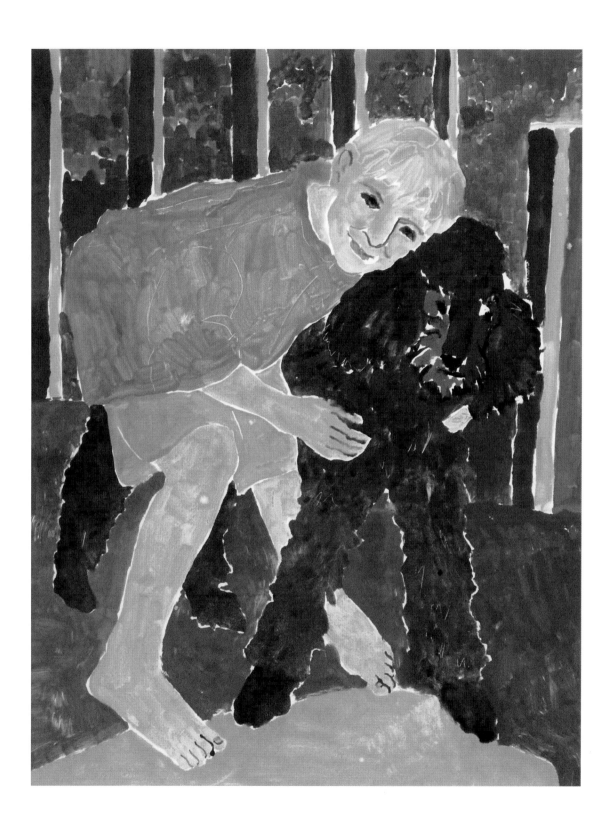

Aaron and Charlie 2007
Monoprint 23.5x 18.5 inches

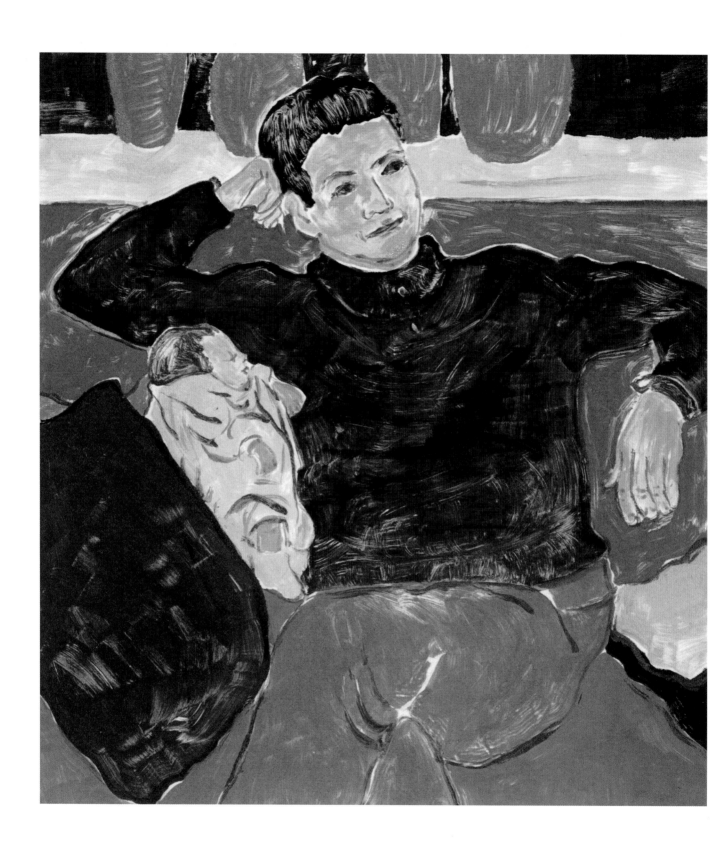

First Born, Andrew and Michael (above) 2008
Monoprint 16 x 14 inches

Ginny and Vicenzie (right) 2007
Monoprint 24 x 19 inches

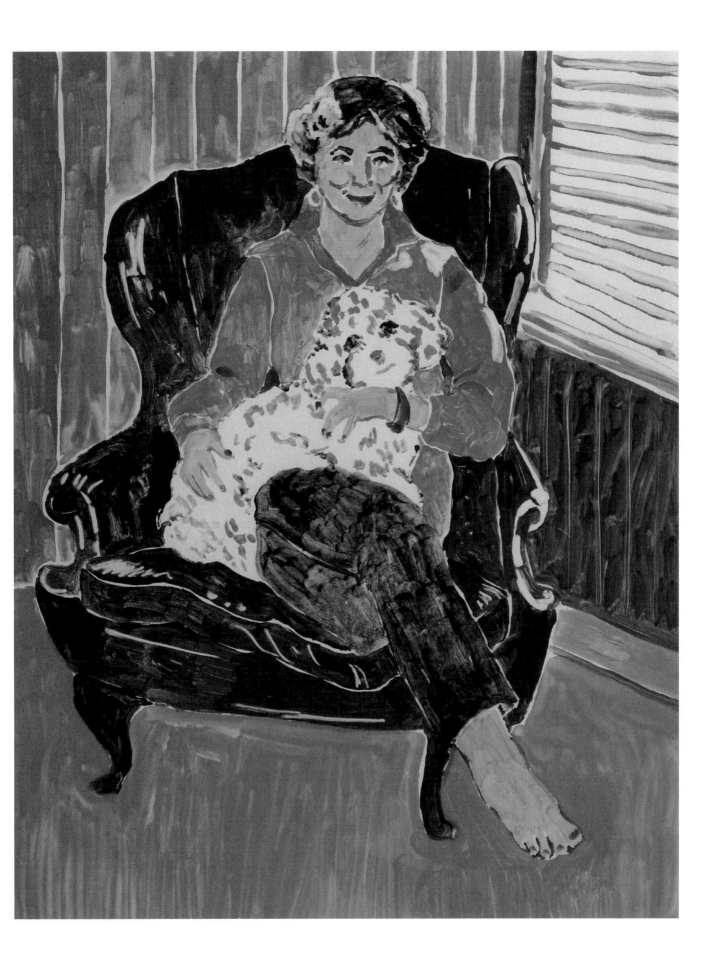

Inky Contemplating Green Asparagus 2006
Monoprint 17.5 x 25 inches

Thank You, Helen Cullinan

Helen Cullinan, the *Plain Dealer's* former art critic, died recently at the age of 86. I'm grateful to her because of a conversation we had a number of years ago.

I had invited Helen to come to my home studio to see a newly completed painting, and she was kind enough to do so even though I was not a well-known artist at the time.

Sitting with her in the living room, I shared that a high-profile couple in our town who loved to cook, were making a cookbook which highlighted foods from restaurants they'd enjoyed while traveling. After searching through the NOVA arts organization slide files for an artist-illustrator, they selected me!

I was flattered but dubious, fearing that with no illustration training I'd be unable to do the job properly. Yet I was curious and eager to try, and they were willing. I completed a painting and several images and sent the samples to their New York publisher for approval.

During that time, the famous British Indian writer Salman Rushdie was accused of heresy by Islamic religious leaders. In 1988, they declared a fatwa throughout the world against him and any publishers of his book *The Satanic Verses.* When the cookbook publisher did not even reply to the Cleveland authors regarding my artwork after months of waiting, I was told the editors were terrified by the fatwa's threat and not working well.

And so it dragged on until I was sent a $200 'kill fee' in payment for my time.

Depressed about the rejection, I confided all this to Helen. She reacted swiftly, "You are a professional artist. Get over it!" Helen continued, "Almost every time I write an article or review, some parts will be cut, often the parts I cared the most about. But it's part of my job, and I have to accept it."

Afterwards, we climbed the stairs to my studio where Helen admired and praised my new watercolor still life. Occasionally, I recall her kindness and, sometimes, I remember to heed her practical advice.

Thank you, Helen.

Gloria Plevin
June 2, 2017

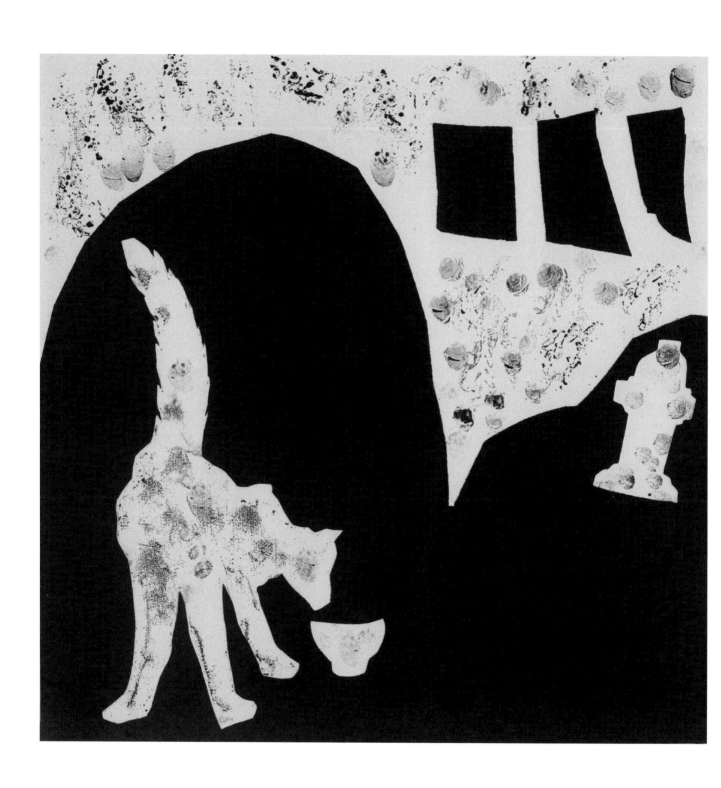

Cat Suite #3 (above) 1992
Monoprint 13.5 x 13.25 inches

Cat Suite #5 (right) 1992
Monoprint 13.5 x 13.25 inches

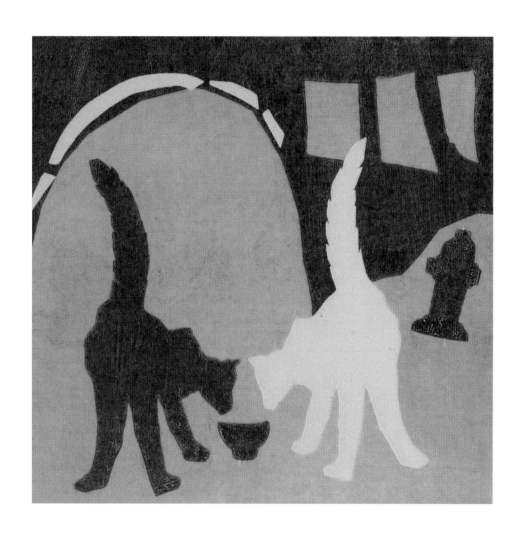

Fiddleleaf Fig, Cat and Turquoise (left) 1991
Monoprint 15 x 20 inches

Young Cow in a Meadow (above) 1992
Monoprint 10 x 10 inches

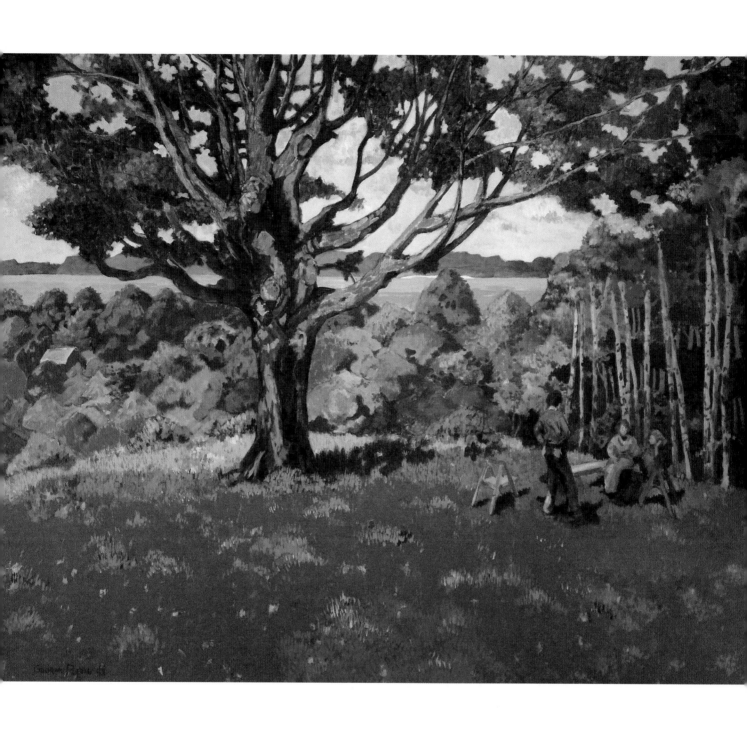

Conversation on Potter Road 1993
Acrylic 48 x 62 inches

OUT AND ABOUT

Conversation on Potter Road

Cold, blustery snow.

It's been such a mild winter that today's storm is exciting, but I'm glad it waited until today and not this past weekend when our kids came flying in from NY and driving in from Chicago for Leon's 60th birthday celebration.

Here in my studio, all is cozy and warm. I'm sitting and looking at the painting of the girls in conversation under the big old tree at Chautauqua. It's almost finished and really grand. I expect to complete it in the next few days and have ordered the stretchers and canvas for the next one, same large size.

Gloria Plevin
From my diary
January 14,1992

Water Reflections

As a small child, my first memory of water was a creek near my home in Clarksburg, West Virginia, a town in a valley surrounded by the Appalachian foothills. A swinging bridge dangled over that creek, a scene I found so frightening I sometimes had nightmares of struggling to swim across, never reaching the other side.

Decades later, my family of husband Leon, four children, a dog and various cats, spent our summers one block up a steep hill from Lake Chautauqua in New York state on the grounds of the Chautauqua Institution. Unfortunately, the lake view from our old home was blocked by a good-sized hotel. My kids swam in the lake daily and learned to sail.

Our first boat was a lovely, old wooden Chris-Craft named West Wind. Leon studied the rules of driving on the 20-mile-long lake as did each of our children when they turned 14. We enjoyed taking friends for boat rides, getting friendly honks from other Chris-Craft owners on the water. One visitor from India wore a sari which was wrapped just so around her young figure. When the waves heaved, spraying all the passengers, her sari was soaked. Fortunately, she just laughed along with the rest of us.

As an artist, I was surprised at the sky filled with mammoth white clouds over the water and continually intrigued with the cottages and boatyards along the lakeshore. Eventually, we replaced the Chris-Craft with faster, smoother boats, yet its memory still makes me smile.

When we moved into a retrofitted 100-year-old barn beside Route 394 a few years later, I asked Leon if we might buy a couple more acres so no one could build behind us. He surprised me with a deed for 60 acres of woods, an overgrown apple orchard, and fields full of wild flowers and ferns. After clearing several acres of tangled old brush, Leon built two large ponds, each ten feet deep. We stocked them with four-inch koi, carp, and little bluefish that arrived by mail in cartons of water. My sister-in-law Marilyn and I dumped each carton carefully into the ponds. The fish grew and grew so that, in a few years, each unique and beautifully patterned koi was two or more feet long, as large as the koi gracing the Emperor's fishponds in Tokyo.

The Mayville boat marina was a fascinating, beautiful place just across the road from Dick's Harbor House restaurant. I always chose to sit by the window while eating my fish sandwich and sipping a chocolate milkshake so I could admire the scene of the docked boats bobbing at the marina.

Gloria Plevin

Marina (detail) 1999
Acrylic 40 x 45 inches

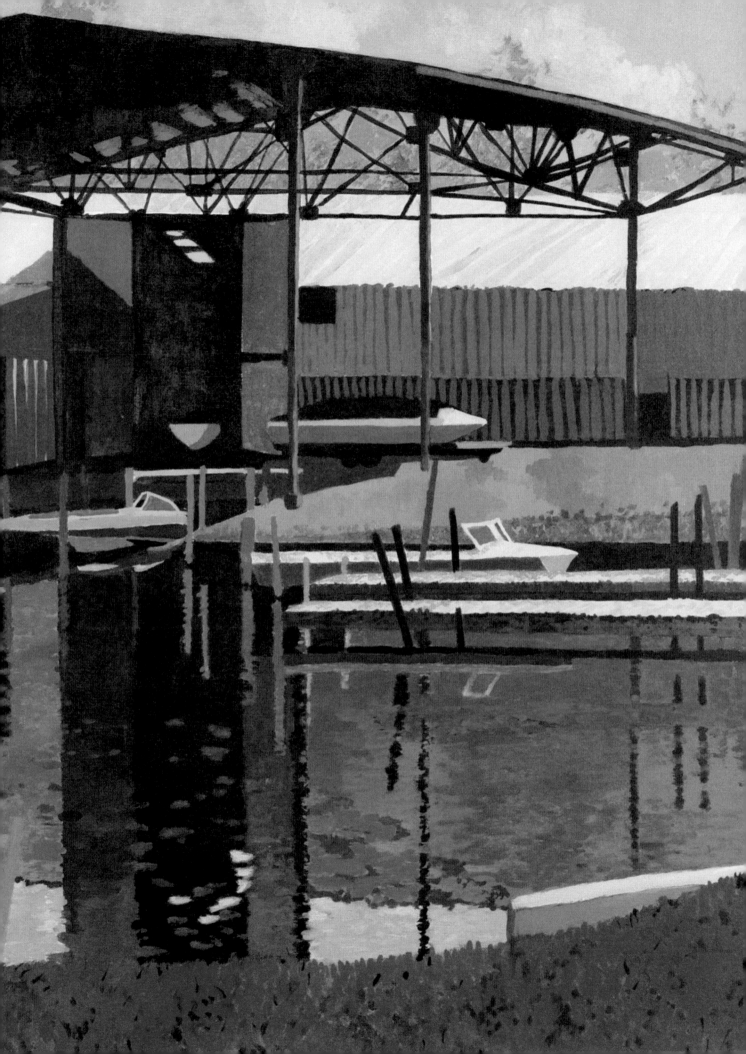

Searching for the Unexpected: Painting Landscapes

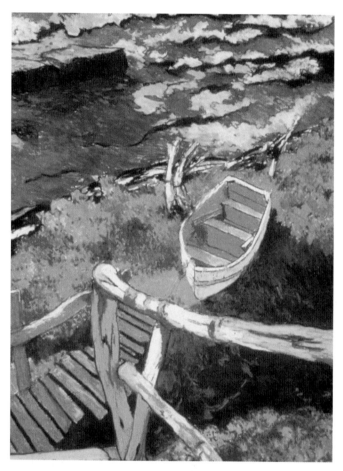

Off Route 2 near Westfield, New York, the lane was lined with old sycamores. They were lovely, providing shade from the hot summer sun of 1995. My friend Bob Rader who lived near the far end of this road with his wife Sherry, told me that each sycamore sheds its bark annually and then grows new bark, tinging the large trunks green.

Driving slowly past cottages on either side, I arrived at the Raders' for the first time. After a pleasant chat on their screened porch, Bob and I walked to a grassy area, then carefully descended concrete steps to a green promontory. The next set of stairs and railings were unpainted raw wood; the entire jiggidy-jaggedy enterprise looked dangerous, but the view was tantalizing.

The wood steps led down to a narrow beach which was entry to the vast blue and gray waving waters of Lake Erie. And, waiting there on that shore, I saw a bright orange rowboat.

Before I could get closer, my fear of looking down from high places kicked in. My body stopped cold, but my imagination shifted into high gear as I remembered the Japanese prints that Leon and I had recently discovered at our friend Michael Verne's gallery.

In my mind's eye, I saw a vertical painting. From the top, rickety steps zigzag down to a rugged beach where, unexpectedly, an empty orange rowboat waits. The water stretches beyond with lapping waves that threaten or invite. Thrusting irregular forms and steep perspective create visual excitement enhanced by the boat's orange color and dramatic surroundings. Each part of the picture adds to a sense of adventure.

Within a year, I completed two pastel paintings, *Lane of Sycamores* and *The Orange Boat.*

Gloria Plevin

The Orange Boat (above) 1995
Pastel 22 x 16 inches

Sycamores (Lane to the Lake) (right) 1995
Pastel 27 x 22 inches

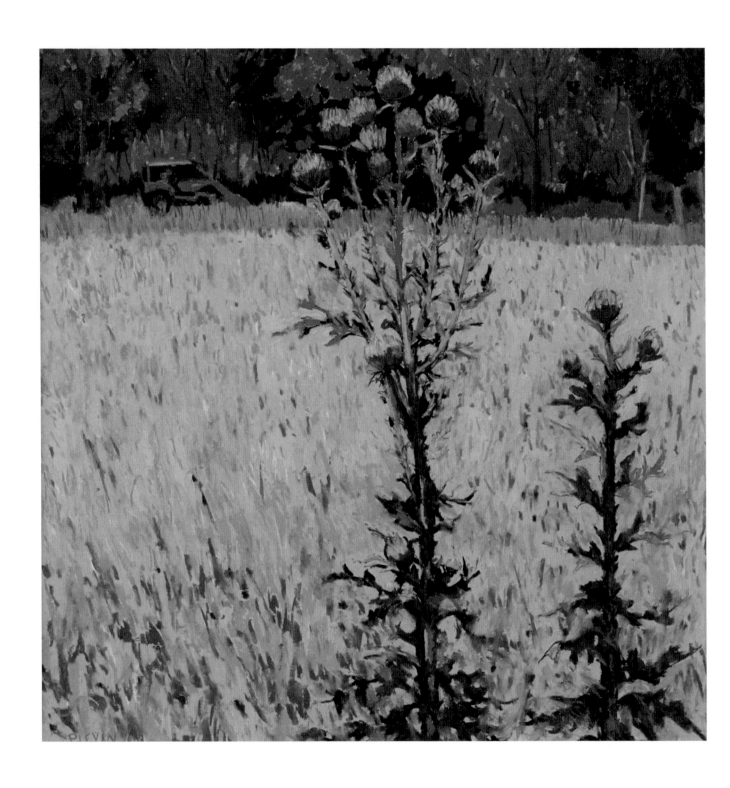

Canadian Thistles and Tractor 2001
Pastel 28 x 27 inches

Tractors, Meadows and Wildflowers

Until the tractor-mower arrived, the field looked pretty ordinary, just a meadow turning brown in August, full of tall grasses with hardly any blooming flowers. Except for the Canadian thistles with their puffs of pinky-purple blooms atop three feet of exceedingly prickly stems and leaves. So the sound of the tractor making paths up and down to cut the blowing grasses sent me running for my camera to capture the thistles before they were destroyed. That confluence of meadows, tractor and thistles stirred new paintings in my mind's eye.

Days later, with a dozen snapshots of the meadow pinned up for study in my studio, I began a new series of pastels, the latest in my paintings inspired by scenes around Chautauqua County. Like the impressionists whose work is forever associated with certain towns in France, I had decided that the Chautauqua countryside was so lovely I wanted to devote myself to portraying her beauty. Earlier series included monoprints, pastels, and large acrylic paintings that included a 12-foot long diptych depicting hand built Amish haystacks, a painting of a huge, grape harvester in Westfield, and another 12-foot diptych of the sun setting on hundreds of ducks floating on the harbor in Barcelona.

After 16 years, the markets, ponds, woods and fields around our property on Route 394 and beyond, still offer me fresh, exciting images to paint in every season.

Gloria Plevin
May 2002

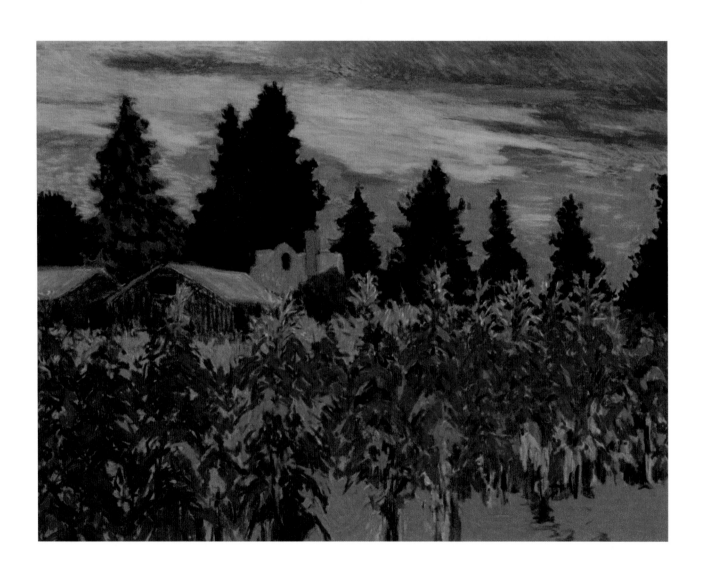

Mr. Fisher's Little Corn Patch (above) 2001
Pastel 18 x 24.5 inches

Haffenden's Farm (right) 2014
Pastel 18 x 24.5 inches

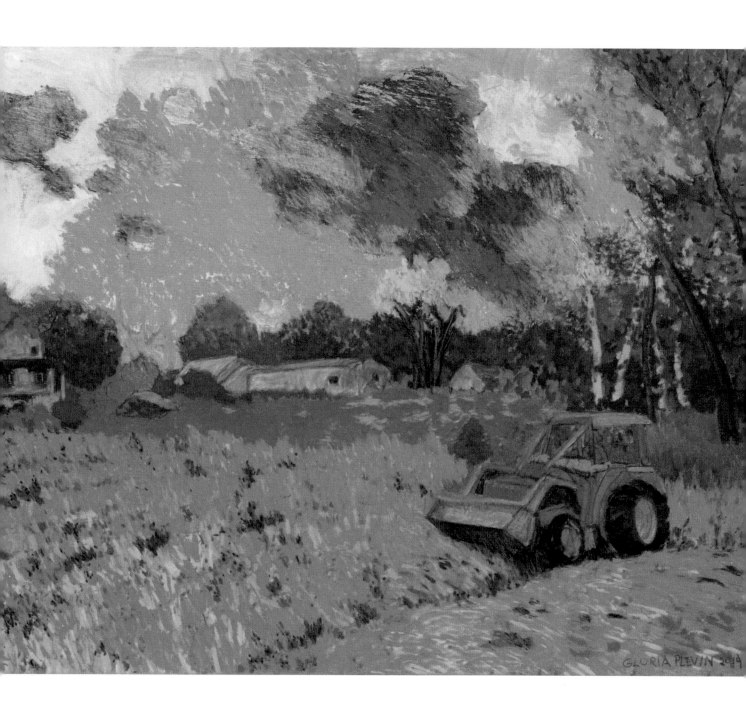

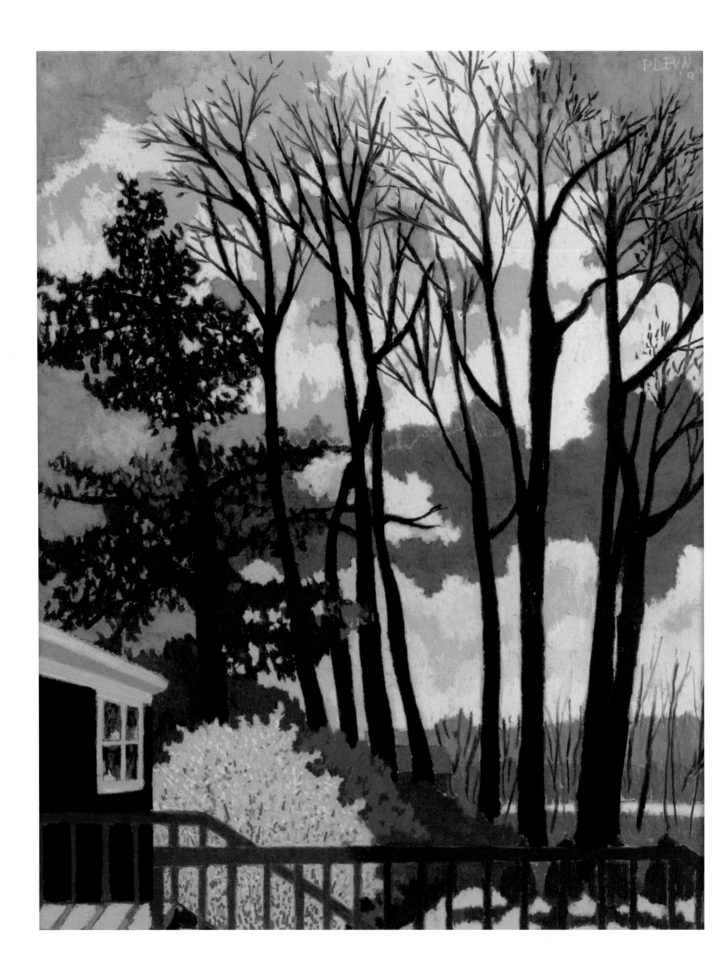

Cottonwoods/April (above) 1999
Pastel 26.5 x 21 inches

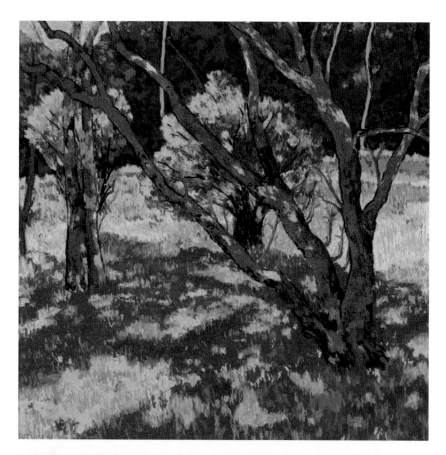

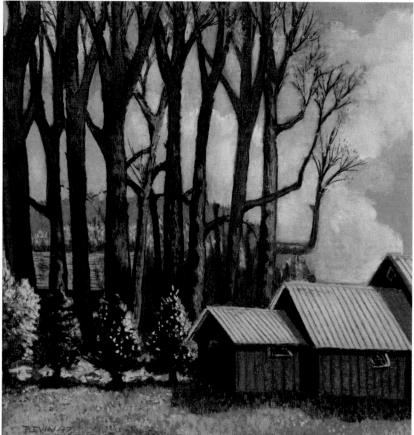

Old Orchard in Summer (above right) 1994
Pastel 20 x 20 inches

Cottonwoods and Cottage (below right) 1997
Pastel 22 x 20 inches

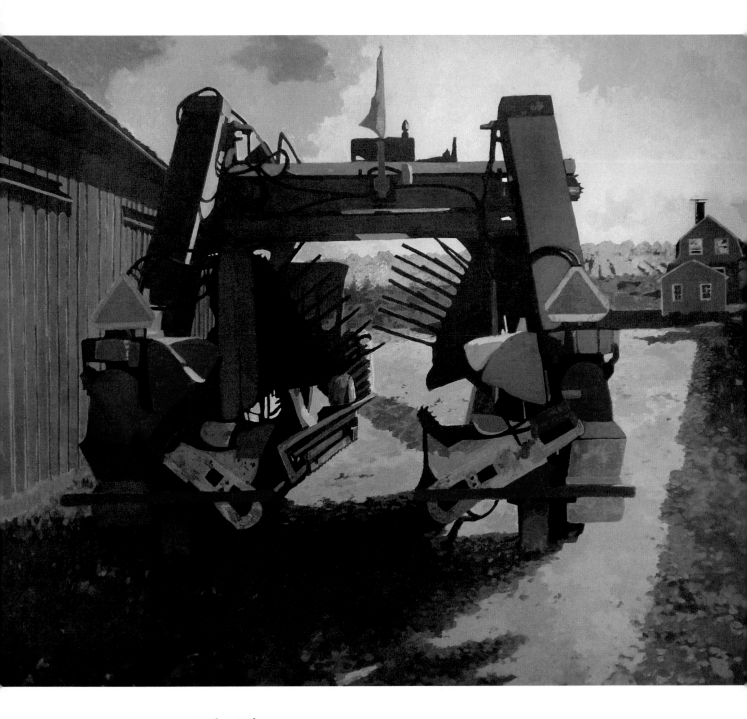

On a Morning Like This

On a morning like this heading down Route 394 towards Westfield and beyond, the air is clear, and it is a lovely day to be alive. Photos of this and that will come home to my studio and, eventually, a wonderful painting may come about.

Beckoning images are all around. And also the opportunity for breakfast at Mayville Diner or the pancake house hidden deep in the grape-growing acres near Lake Erie. At a farm stand on Route 20, just-picked corn looks tantalizing to bring home for dinner. Hillsides are loaded or recently picked, and fields are turning golden. A huge grape harvester waits for the one driver who alone replaces 100 pickers in a vineyard. Life is good.

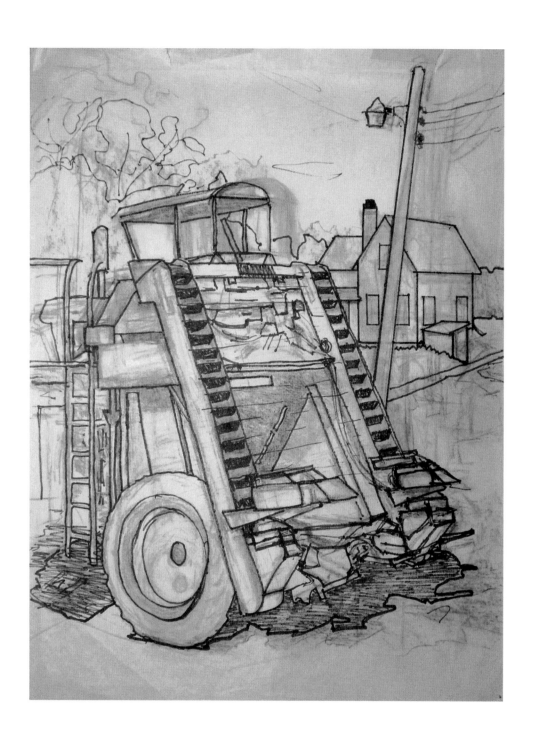

Grape Harvester (left) 1995
Acrylic 48 x 60 inches

Grape Harvester (above)
Pencil and ink on paper 22 x 18 inches

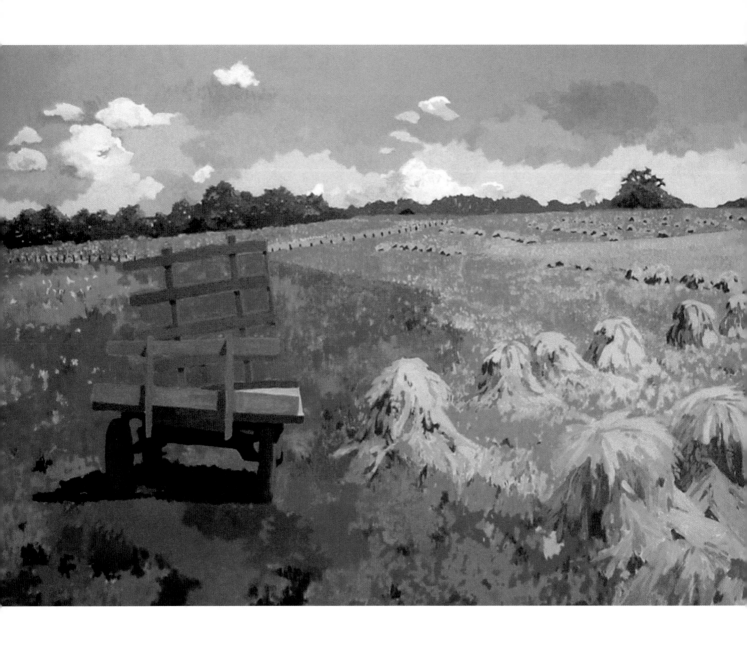

Amish Field and Stacks 1994
Acrylic diptych 48 x 142 inches
Courtesy of Artist Archives of the Western Reserve

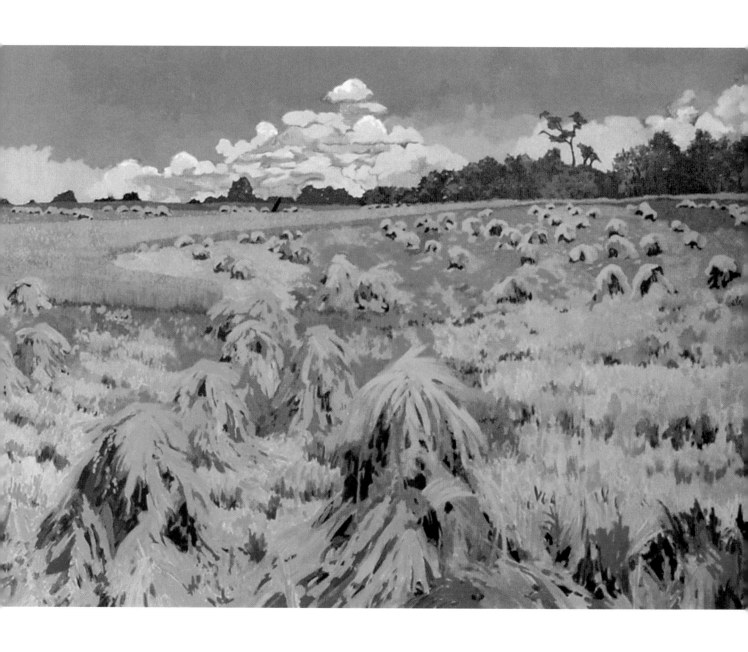

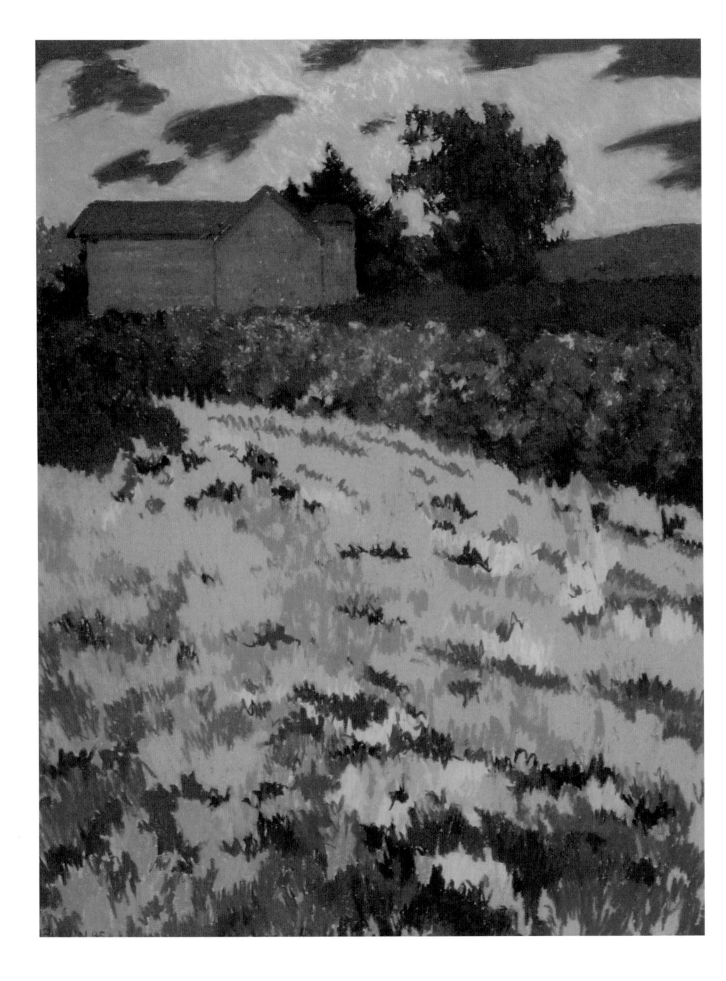

Chatauqua Barn and Field (left) 1995
Pastel 25.5 x 19.5 inches
Courtesy of West Virginia University Art Museum

Rte. 394 / August (right) 1997
Pastel 18 x 24 inches

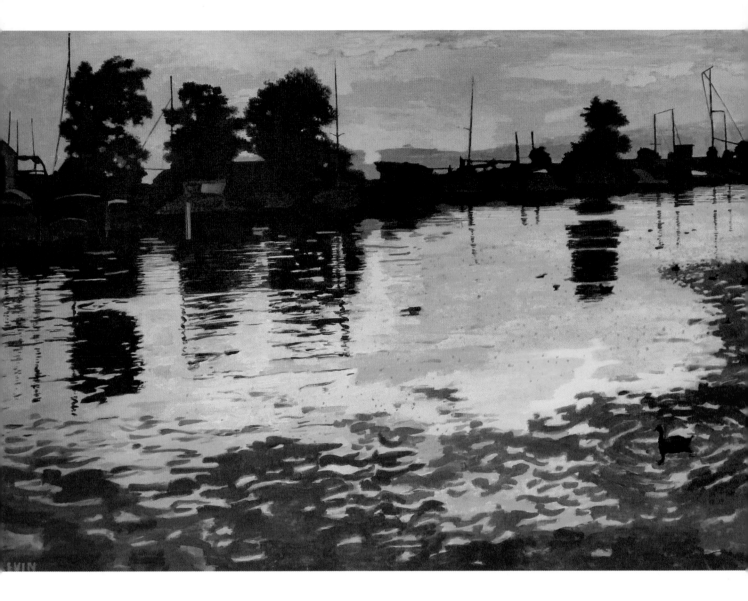

Water and Light

In the first week of May 1961, my husband Leon and I made our first trip to Paris. Delighted to be in this city of art, we wandered into a small museum featuring the show France and America in the 19th Century. When we recognized Thomas Eakins's painting of the Biglin brothers on loan from the Cleveland Museum of Art, we felt as if we had bumped into an old friend far from home. I was particularly impressed with Eakins because he was so interested in people. Even though the rowers' faces are in shadow, their expressions are powerful, as is the expression in the muscles of their arms as they row. When the Cleveland Museum of Art mounted a small didactic show *Thomas Eakins: The Rowing Pictures* in February 1997, I had in the meantime become the mother of four children, an artist with a career, and the owner/director of an art gallery. I had begun a series of large paintings (some 12 feet wide), and I had an idea for a new one. It would be a large painting of the sun setting over the harbor on Lake Erie at Barcelona, New York. I had taken photographs, but otherwise had no inkling of how to make it happen. I grew up in a small town in West Virginia where there was a creek, and that was all the water there was!

Barcelona Harbor, NY 1980 Acrylic diptych 48 x 142 inches
Photo of Gloria Plevin by Cleveland Museum of Art

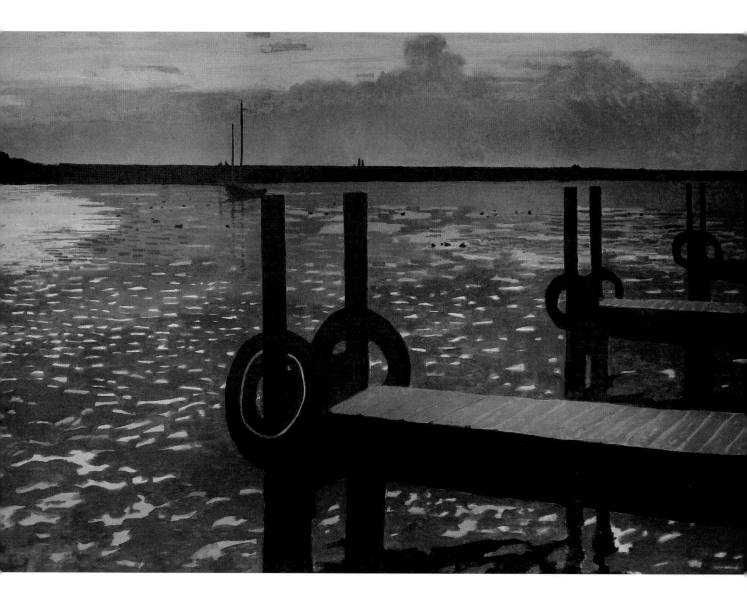

That year, Jesse Rhinehart was teaching an art class at the museum looking closely at the rowing paintings. "Here is my opportunity," I thought. With pencils, rulers and papers, we novices approached the paintings. Jesse showed us Eakins's pencil sketches—perspective studies on the bridge, the boat, the water, the rowers, and the far shore where spectators were gathered. Even the waves—every little thing was part of the same system. I, who had nearly flunked plane geometry, tried to apply Eakins's linear, precise techniques to my own feeble drawings of the fountain and courtyard in the heart of the Cleveland museum. My drawings were discouraging, but I did learn that, as an artist, I had to find my own way. It doesn't matter if it's exactly right; it's just about making it convincing. It has to be convincing.

Eakins is absolutely convincing, even down to the hands gripping the oars, oars dipping in the water, the crowds on the shore. I abandoned his precise preparations in favor of a creative solution in keeping with my own capabilities and personality. At Zygote Press I made a small etching in which the water glowed with the fiery last light of the sunset. Bathing ducks made circular swirls in the water. From the evocative little etching, I proceeded to a 12-foot painting, *Barcelona Harbor*. Glittering golden fragments were scattered on deep blue water, and all were watched over by black brooding boat docks. This glowing harbor panorama became the focal point of my retrospective at the Chautauqua Institution in the summer of 2007. I credit *The Biglin Brothers Turning the Stake* and Eakins's other rowing pictures for the inspiration.

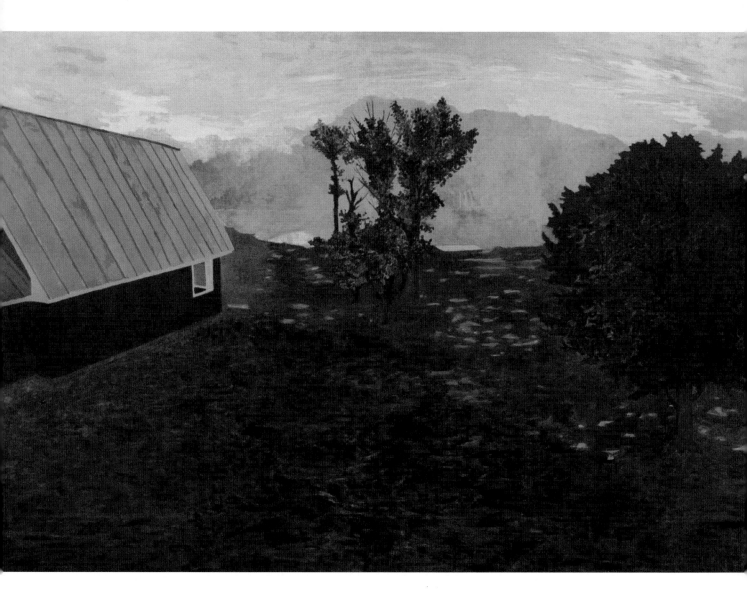

A New Bird and a Bobcat

It was early morning in late August, and I had already said goodbye to many friends on the Chautauqua Institution grounds a mile up the road from my country place. While glancing out my kitchen window, I saw a bird sitting nearby on the porch railing. The bird was looking around, quite interested in observing my deck. Was he (or she) considering if this was a good place to nest?

The bird was new to me. It looked almost like a mourning dove, about the same size as a dove with upright posture and a quiet, self-assured demeanor, but its color was unlike any bird that had visited my bird feeders all summer. The bird was beige. It was beige all over. No stripes, no dots—just a few fluffy feathers around its young, proud beige neck. Then it flew away.

A New Day 1998
Acrylic 48 x 68 inches

Two weeks later, while reading a news article about the Passenger Pigeon, a bird that everyone knows is extinct, I was startled to see a picture that bore a strong likeness to 'my bird.'

A quick look at Wikipedia gave me pages of information about the Passenger Pigeon, its history, and eventual demise. There were flocks so enormous that, when they flew overhead, they blocked out sunlight. Millions became food for Indians and rifle practice for hunters until there were only a few who no longer mated. The last known Passenger Pigeon was named Martha, and she died in a zoo in 1914.

What am I to do with this encounter? A few friends who are willing to listen suggest contacting The Audubon Society or the Natural History Museum. Perhaps the Roger Tory Peterson Institute? When I have more time, I will begin some inquiries.

In the meanwhile, I fantasize about a bird and animal sanctuary within the sixty acres of woods, meadow, and ponds that make up my property. Is this pale beige bird an omen for the future? And, if I let it be known, will I in any way jeopardize a potential rebirth of a species heretofore considered to be gone from the planet? Come on, Girl, that is just too way out. But what about the fairly recent sighting of a bird in a Southern woods suspected of being an extinct woodpecker? What an odd and unexpected turn of events to mark the end of my 80th birthday summer.

After returning to my Cleveland apartment, I had a phone call from Richard, the sturdy, multi-talented, retired mechanic who oversees my property. He tells me about something he saw while mowing the meadow next to my woods. According to Richard, he noticed movement in the tall grasses and stopped the big, red farm tractor on which he sat. There, 200 feet away, stood a bobcat. Twice the size of a housecat and brown, Richard recognized the wild predator that is normally a night hunter— not out roaming at 2 p.m.

A Vietnam veteran, Richard knows exactly how to be still. The bobcat's prey are small animals such as mice, squirrels, and geese, but Richard also knows that a bobcat can leap many feet to attack a deer. Up on his tractor, this man, over six feet tall and 220 pounds, sat immobile for half an hour as the bobcat, keenly aware of him, bounced and pounced, jumping closer and closer. So close that Richard could clearly see its brown back, the black stripes on its gray sides, and its white under-belly. Stiff black hairs stood out from its ears; its tail was short, and it had big round paws. Now, only a few feet away, the bobcat sat, staring at Richard. Finally, not seeing anything resembling supper, it quietly disappeared into the nearby woods.

Riding down the hill through the woods after he finished mowing, Richard saw a large buck with huge antlers which he described as beautiful. He also said that when he saw the deer, he thought what a wonderful dinner it would make for his family. Even as he said this, I felt that Richard, a man I greatly respect and admire, was having a bit of fun at my expense. But hunting season is coming along with predators of the human kind in the woods. At my request, Richard will attach bright signs to trees all around the perimeter: Private Property: No Hunting.

Reflecting upon bird and bobcat, I consider how much I've learned from spending the past 30 summers in our old barn-turned-country homestead where my family and often only my citified self and schnauzer Sammy, are surprised and sometimes amazed at this place we call home.

Gloria Plevin
December 1, 2014

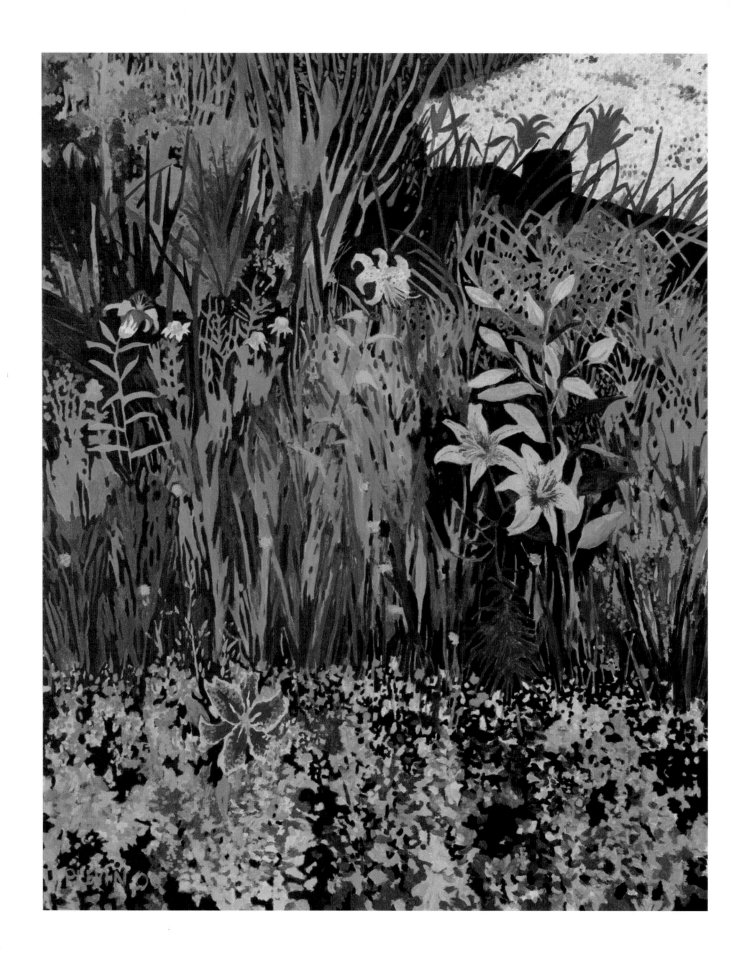

Lilies and Chives 1999
Acrylic 60 x 48 inches

FLOWERS

My Giverny

In 1985, Leon and I purchased an old dairy barn turned gas station turned antiques store in Chautauqua, New York. We retrofitted the sprawling black buildings into our summer home, my studio, and an art gallery. For over 30 years, I cultivated three large perennial gardens in the front, facing Route 394. Many years later, we planted a bed of blue, purple and yellow perennials behind the barn to enjoy as we looked out at two ponds and woods beyond.

With plantsman Randy Nyberg and later, landscaper Jim Mason, we created gardens that were distinctive because of their tall flowers selected to sway in the north and south breezes and nod to passing walkers, bikers, cars, and motorcycles. The garden also acted as a friendly barrier and protector of privacy for myself and my family who lived behind it. A large gravel driveway still separates the gardens from the long black barn with white trim and gray metal roof. For eighteen summers, that barn and adjacent former auction room were the home of the Gloria Plevin Studio and Gallery which I closed in 2002.

The gardens were a work of art-in-progress. Their mixture of cultivated perennials and wild flowers attracted photographers, butterflies, and lots of bees. The plantings not only provided ever-green resource material for my paintings and watercolor Botanicals, they fed my soul.

I was 50 when we moved to 5073 West Lake Road. Eventually, my gardens required helpers. Roxanne Zemcik and her daughter Mary Mowers were careful and sensitive collaborators. Randy Nyberg continued to supply spectacular plants. My darling Leon died in 2008.

Four children and seven grandchildren visited their Grandma Gloria at Chautauqua until I sold the property in 2016. Each summer, I enthusiastically shared my sense of wonder and encouraged my progeny to admire the unique qualities of each new plant and the paintings it inspired.

Gloria Plevin

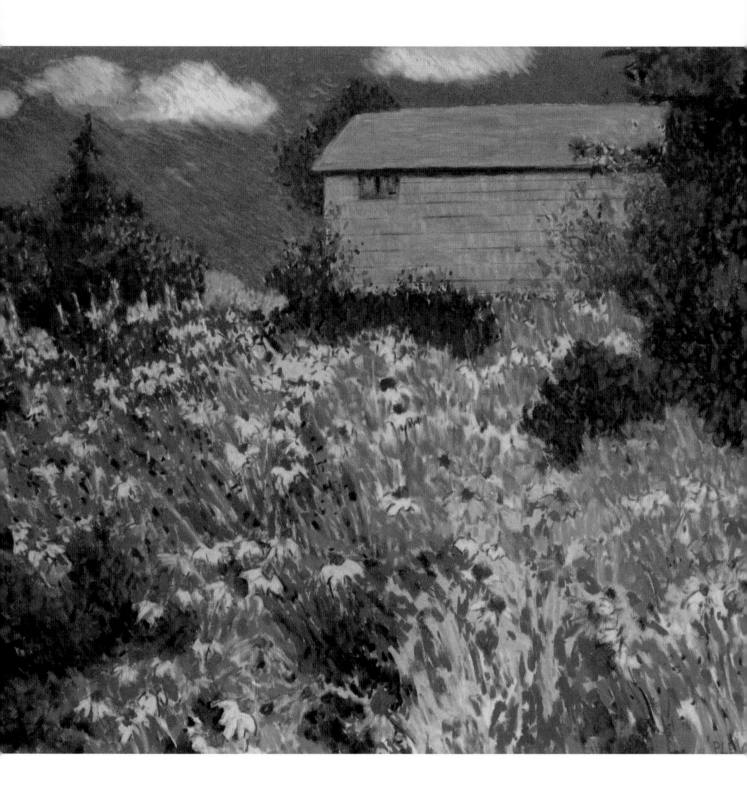

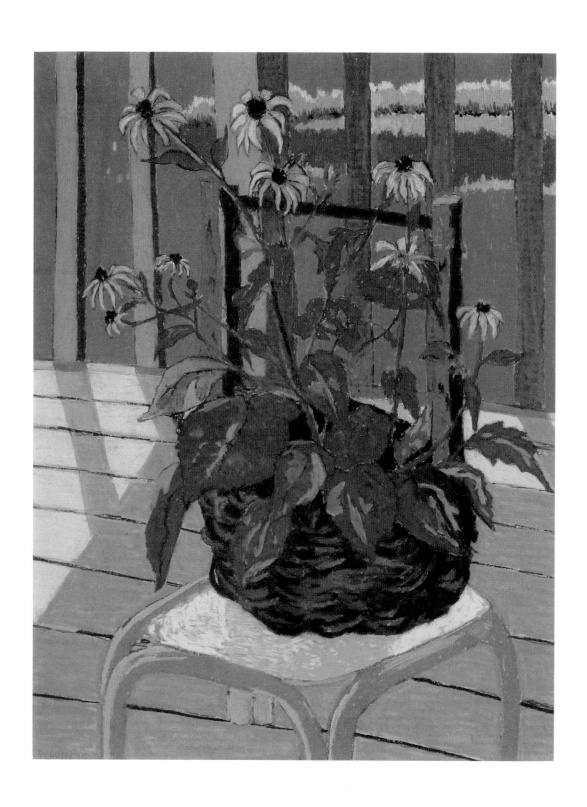

Hillside of Echinacea (left) 2002
Pastel 18 x 9 inches

Black-eyed Susans on Porch (above) 1998
Pastel 26 x 20 inches

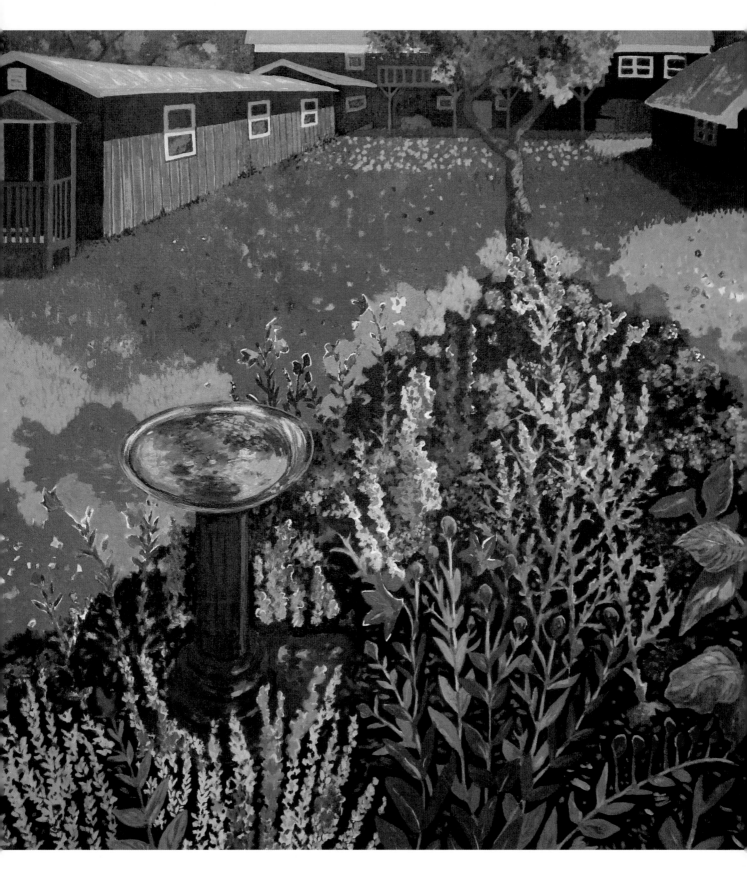

My Blue Garden (above) 2002
Acrylic 48 x 48 inches

Miss Willmott's Ghost (right page, left) 2009
Watercolor 25 x 19.5 inches

Monarda (right page, right) 2014
Watercolor 12 x 9 inches

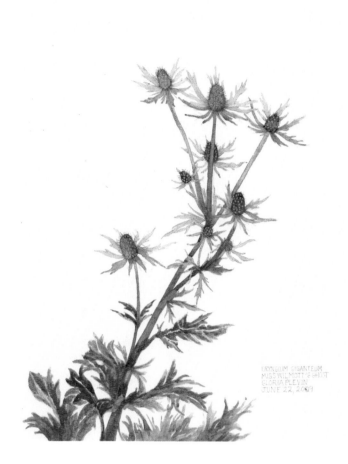

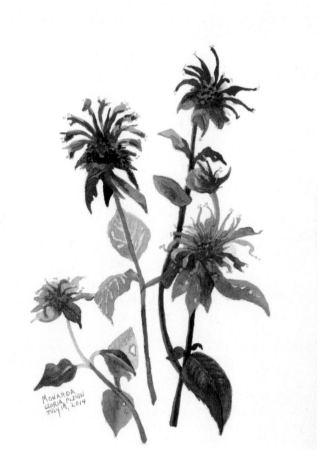

The First Botanicals

It is possible to go to a showing of precious botanical books at a nature center. I attended my first viewing of rare botanical books at the Eleanor Squire Library of rare books at the Holden Arboretum near Cleveland. Dr. Stanley H. Johnston, Jr. introduced visitors to examples of the first botanical books which were illustrated in black and white woodblock prints. They were precise renderings of many plants used by physicians in the treatment of various conditions and diseases. These books preceded the use of the printing press. The artist needed to be exact so that the gatherer of the plants would be correct in the picking and preparation of the medicine.

When the printing press was invented, the illustrations were done in black and white and colored by hand. Beautiful renderings of flowers, fruits, insects, and wild life became popular. The originals were copied and sold to housewives, artists, and weavers who made embroideries into works of art and adornment. Botanical artists began to travel with explorers to exotic places. Plants were brought home to rich patrons who grew them in their greenhouses. Prints of the exotica were popular.

Gloria Plevin

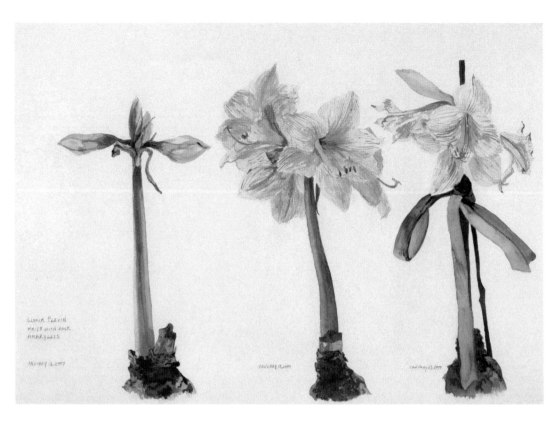

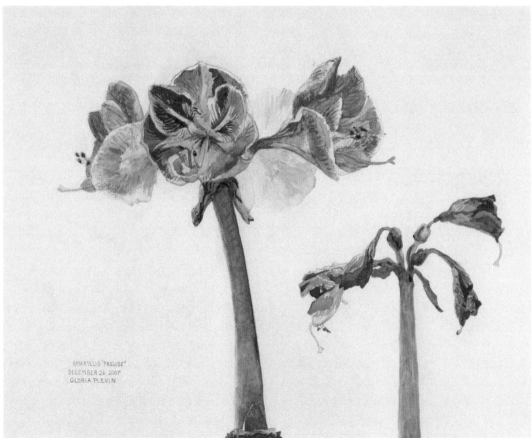

White and Pink Amaryllis (above) 2015
Watercolor 19 x 28 inches

Amaryllis (below) 2011
Watercolor 32 x 24 inches

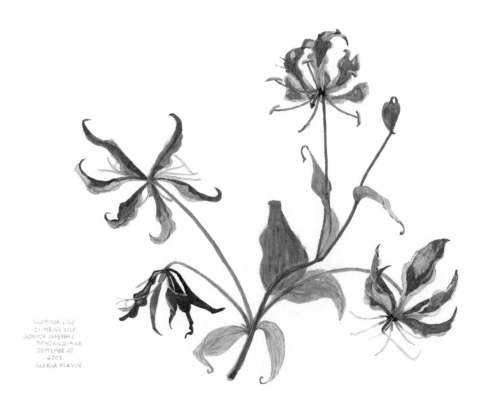

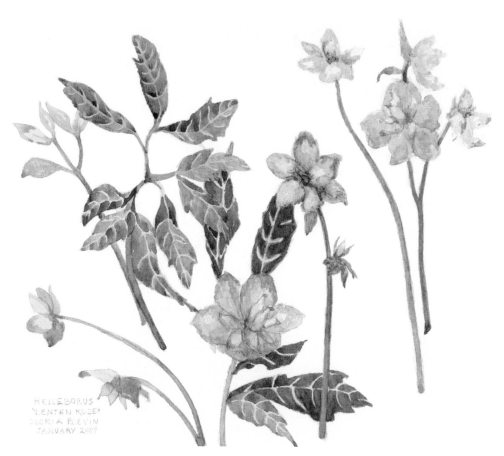

Gloriosa Lily / Climbing Lily (above) 2009
Watercolor 23 x 27 inches

Helleborus / Lenten Rose (below) 2009
Watercolor 21 x 25 inches

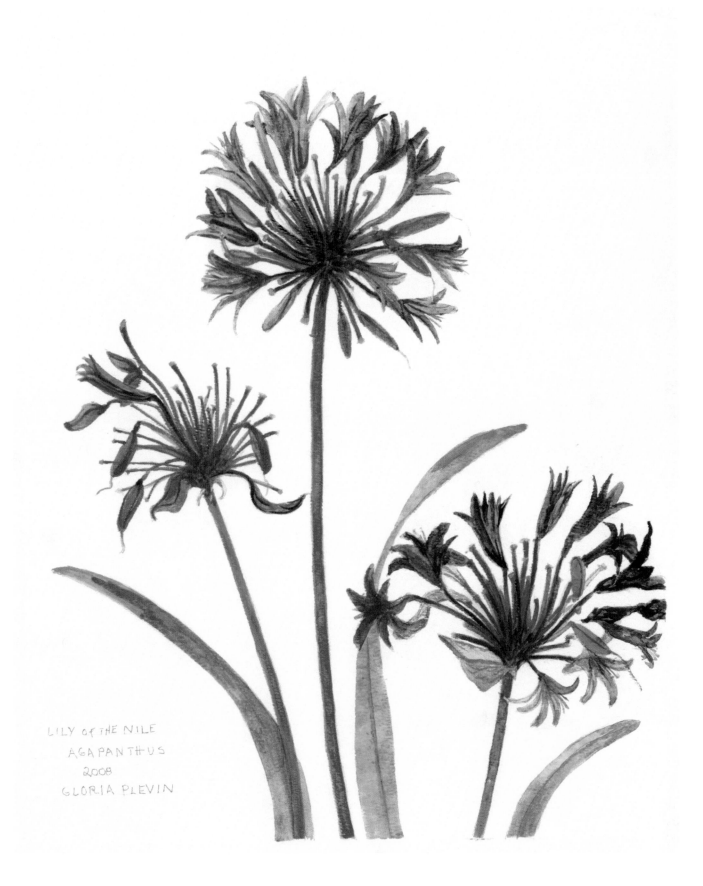

LILY OF THE NILE
AGAPANTHUS
2008
GLORIA PLEVIN

Agapanthus 2008
Watercolor 16.5 x 13 inches
(A wedding gift to Michelle and Frank Gallucci)

Dear Michelle and Frank,

Where did I first see an Agapanthus? I do not remember, but when I saw the exquisite flowers in bloom at the Farmer's Market at Shaker Square, I was hooked for life. The grower assured me that the flowers are perennials and that—even in a moderately cold climate—if certain steps are taken to protect them, they will survive and flourish. He swore that he had been raising them for years.

That summer, I had three exquisite blue flowers from the three plants growing in the semi-shade of a young Japanese flowering tree in my front garden. They had buds by July and bloomed into August. Before leaving Chautauqua, I gave them plenty of fertilizer and mounded up the earth around their bases. The next summer, I was rewarded with eighteen blooms. I read everything I could find about them.

Ah, I have just remembered that the first Agapanthus I saw were painted by Monet with their reflection in the pond at Giverny. So now, Michelle Marie, your name sounds French so it is appropriate that you have this flower painting of the French flower Agapanthus.

When I arrive at Chautauqua on Monday, the first thing I will look for is a bit of the Agapanthus coming up in my perennial bed.

I hope that you and Frank enjoy the painting for many years to come. Be a good friend to the flowers and do not hang the picture in the bathroom—TOO MUCH MOISTURE—or on a wall which receives a lot of sunshine. The delicate watercolors can fade.

I wish you a happy life together. This gift comes from Gloria and Leon Plevin who love you.

Your artist friend,

Gloria Plevin

Flower Poem & Reflections

Flower in the crannied wall,

I pluck you out of the crannies.

I hold you here, root and all, in my hand,

Little flower—but if I could understand

What you are, root and all, and all in all,

I should know what God and man is.

Alfred Lord Tennyson
(1809–1892)

This poem, one of the best-loved in the English language, expresses and suggests so much of the mystery which flowers present to humankind. As for myself, flowers are an important part of my life. When I sit in front of a flower growing on my windowsill in the winter or in my garden in the summer, I am in awe of what I see.

The flower and its plant are growing.
It is changing constantly, at first a bud,
then slowly or rapidly opening,
then turning to the light for nourishment
which it gets from the sun and through
its roots.

As it matures, the flower may change color,
become fuller, moving toward its glory.

When that time has passed, it begins to wither,
but it may also be producing seeds, and before
it is finished, it has prepared the way for the
next generation.

Gloria Plevin

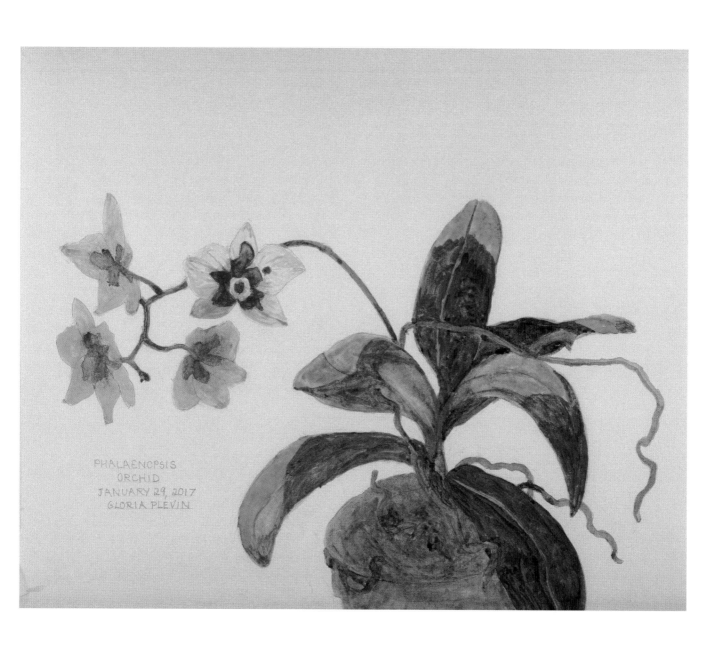

Phaelenopsis Orchid 2017
Watercolor 15 x 18 inches

Flower Beds, Windowsills & Botanicals

Even as a child, I loved flowers, and every summer, my father dug up a flower bed for me beside our home in Clarksburg, West Virginia. I planted seeds for annuals ordered from the Burpee catalog. The fact that I knew the name of every flower in that catalog by the age of ten, made me a wonder child to my Manhattan-bred mother.

At my Chautauqua summer home, I spent decades trying to tame four wildly-growing perennial beds and loved and begrudged the time with bees and worms, stolen from my studio.

In Cleveland, my windowsills are now my gardens. I have come to admire and learn from the masters of Botanicals. Each clivia, orchid, amaryllis, and narcissus is a challenge to grow and bring to flower, a wonder to watch and then, humbly, to paint.

Gloria Plevin

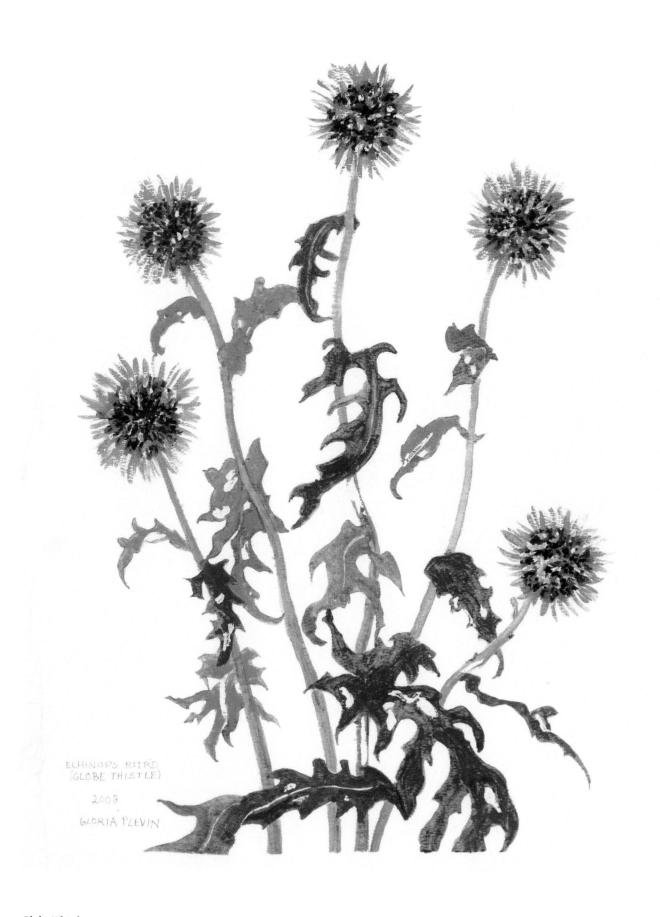

ECHINOPS RITRO
(GLOBE THISTLE)

2003

GLORIA PLEVIN

Globe Thistle 2003
Watercolor 26 x 20 inches

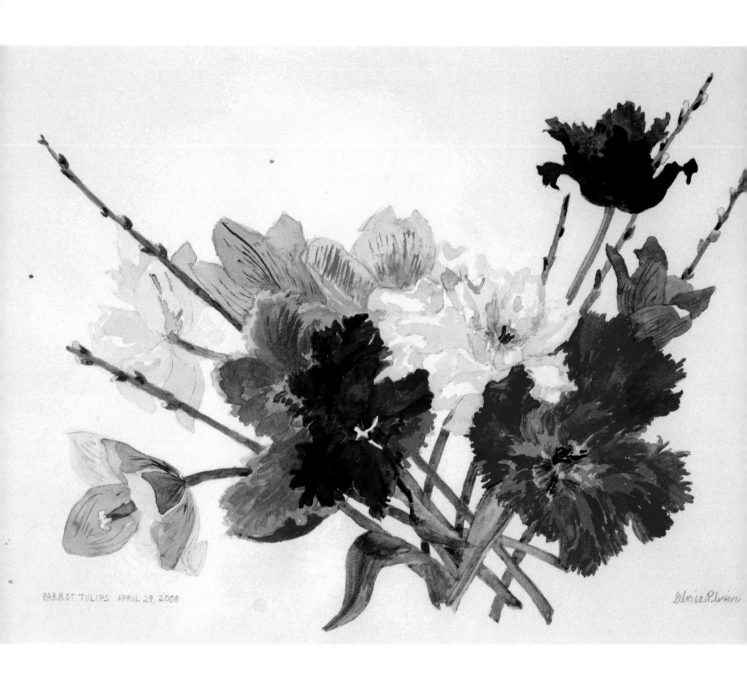

PARROT TULIPS APRIL 29, 2008

Parrot Tulips 2008
Watercolor 15 x 18 inches

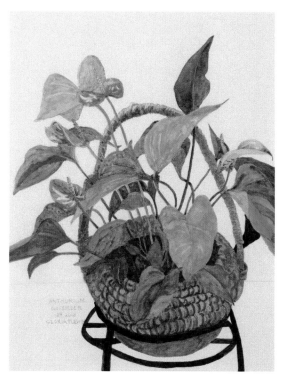

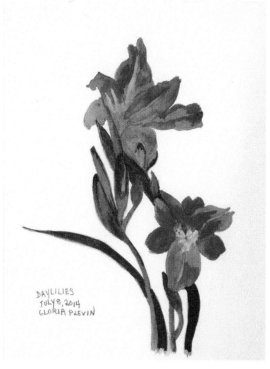

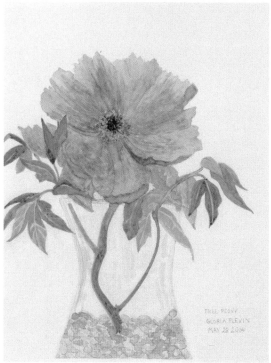

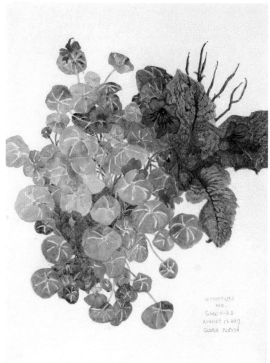

Anthurium (top left) 2013
Watercolor 22 x 17.5 inches

Tree Peony (bottom left) 2014
Watercolor 19 x 14 inches

Daylillies (top right) 2014
Watercolor 12 x 9 inches

Nasturtiums and Gloxinias (bottom right) 2013
Watercolor 22 x 17.5 inches

About Painting Flowers

How odd it might seem that a ten-year-old girl who so loved flowers that she persuaded her father to dig up a good-size garden in their backyard on Maple Avenue in Clarksburg, West Virginia so that she might plant the seeds ordered from the Burpee Seed catalogue so that she could tend and grow the beautiful flowers she admired and then she did not paint flowers for many years until she was secure enough in her art-making career to not worry if a flower painter would be taken seriously by other artists.

Gloria Plevin

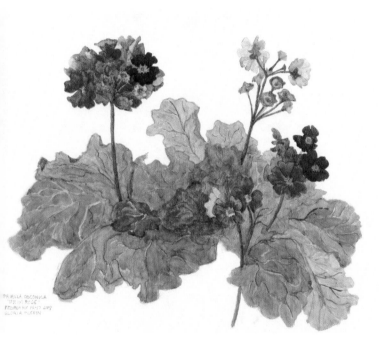 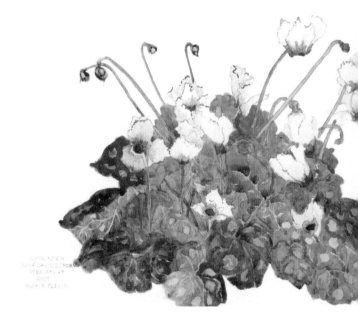

Primrose (above left) 2009
Watercolor 19.5 x 25 inches

King David's Crown (above right) 2009
Watercolor 20 x 26 inches

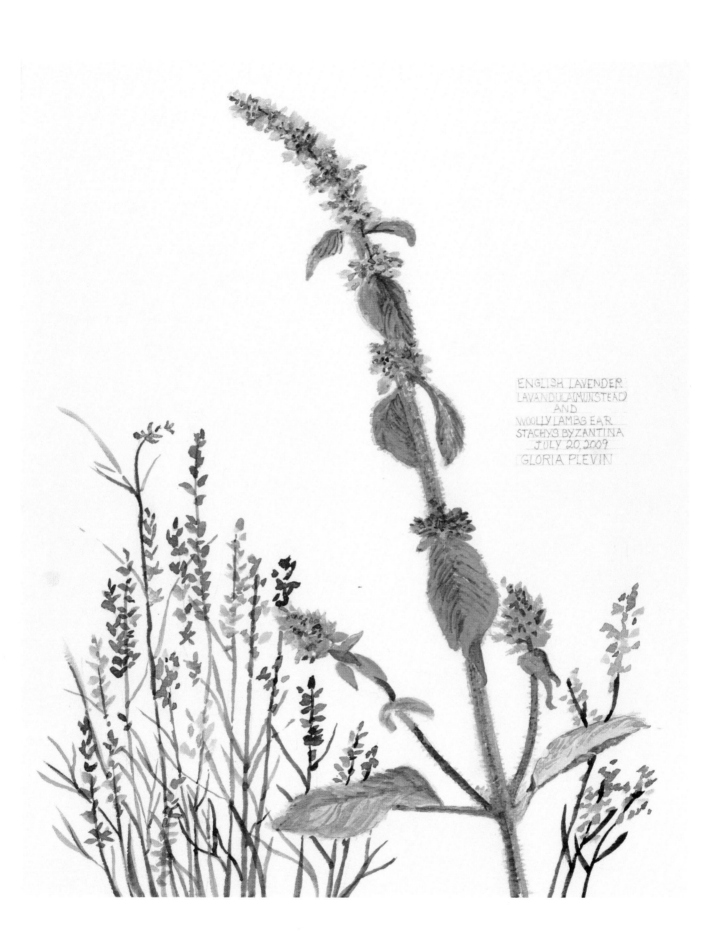

ENGLISH LAVENDER
LAVANDULA (MUNSTEAD
AND
WOOLLY LAMBS EAR
STACHYS BYZANTINA
JULY 20, 2009
GLORIA PLEVIN

English Lavender and Woolly Lamb's Ear 2009
Watercolor 25 x 21 inches

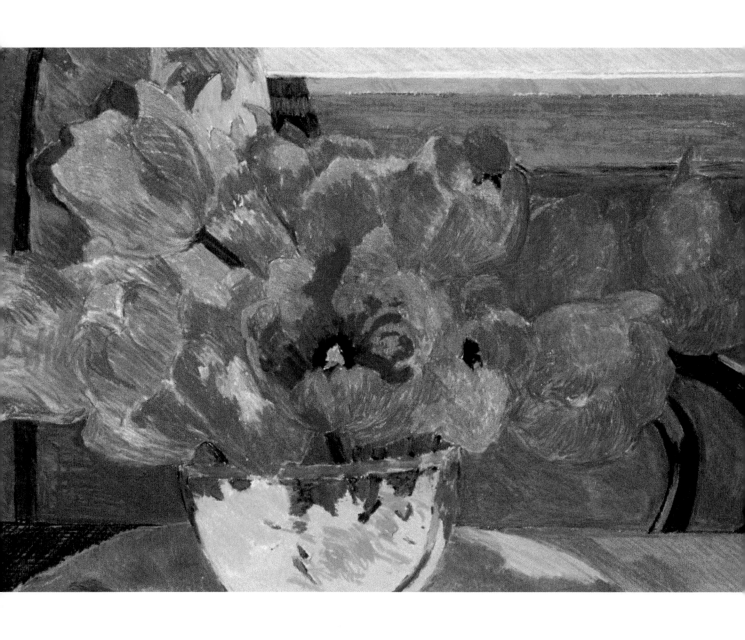

Tulips in a Blue Glass Bowl 2009
Pastel 20 x 24 inches

Hail

Ping! Ping! My attention flew to the window. Ping! Ping! Ping! Ping! Outside, hail flew, hitting harder and louder. The small frozen balls drew me away from making breakfast for my guest who would arrive shortly. Memory is an elusive friend, intruding into the present uncalled for, surprising me with the familiarity of long ago. In a few minutes, my godson Chuck Fink, a talented folk singer, arrived to bring me back to the present, looking damp as he told me that the hail was slippery underfoot.

In the two hours of our catching-up chat over breakfast, I told Chuck the story I had just recalled:

A long time ago, when Leon was alive, our son Andrew came home from college for Thanksgiving. Though late in autumn, it was not too late to plant bulbs outside our big house on Shaker Boulevard. Leon and Andrew were happy to do the job on that chilly but sunshiny day, to my surprise. We then forgot all about the bulbs until early June when tulips popped up. The flowers were large with straight tall stems. The petals were a gorgeous pinky red, the shade of a juicy watermelon. Those tulips would have inspired any artist, and of course, I decided to paint them.

I was not even aware of a storm the next day. Perhaps it didn't rain in the neighborhood I visited. I have been told that it hailed briefly. When I came home and strolled to my front yard, I discovered with horror that every exquisite tulip lay on the ground. Each flower was placed side by side in the same direction, stems and all, as if a naughty child with scissors had mischievously or malevolently snipped them off. What could have happened?

Did I find ice crystals among the petals? If so, I don't remember. But I did recall the saying, "When life gives you lemons, make lemonade." So I gathered an armful of tulips, put them in water, and shortly after, began to paint them.

After arranging the stems gracefully in a blue glass bowl, I chose pastels to make the flowers as close to their original color as possible and went to work. Eventually, unhappy with the result, I set the picture aside.

Months later, Elizabeth McClelland, who was writing a monograph about my art, came to my studio. She was struck by the painting. When I confessed I wasn't satisfied, she encouraged me not to give up. Buoyed by her enthusiasm and, I believe, good judgment, I went at it again. This time, I was pleased.

I framed the picture and hung it in my Chautauqua gallery. Joyce Gulden, a customer who has become a collector, saw the painting, lingered, then suggested to her husband that Tulips in a Glass Bowl could be his birthday gift for her.

My paintings are like my children: When they leave home, they take on their own lives and stories. So it is with my tulips: Victims of hail, but in the end, they are loved.

Gloria Plevin

Little Things Can Make Me Happy

All day, I watched the dark sky for a predicted storm. For the first time that night, I hoped to go to our congregation's annual picnic and Sabbath service, hosted by our friends Aurelia and Julio Pelsmajor in the back yard I'd heard so much about over the years. Luckily, by evening, the air remained delightful.

During 30 summers living beside Rt. 394 in Chautauqua, my three flower gardens, full of bees and butterflies, greeted me each morning. My 'Giverny', I declared to family and friends. Gallery visitors and passersby enjoyed the view, grandchildren cut flowers for bouquets, and I snapped photos for pastels and paintings. Now, walking into our friends' back yard far from Chautauqua's splendid surroundings, I found myself in a hidden paradise.

Neighboring yards were neat as golf courses—green grass mowed low, a few young trees, and open sky. On the Pelsmajor grounds, a wall of greenery featured mature trees, all sorts of bushes, apple and other fruit trees, and near the ground, perennials and wildflowers, some in bloom, others waiting to flourish and entertain. As people arrived, one by one or two by two, I savored a private walk through a lush garden path.

Our short outdoor prayer service was brightened by Rabbi Steve's guitar and my friends' voices singing ably in Hebrew. This was the 50th anniversary of the morning my father Sidney had died suddenly at the age of 64, the day after my birthday. I stood to recite the prayer of remembrance with my daughter and goodhearted friends. Delicious vegetarian food followed.

As we began to leave, Aurelia urged us to pause and notice a small plant with a single green bud. We watched silently as the narrow bud opened in a minute to reveal a cuplike yellow flower.

In two days, I would see the tremendously exciting musical *Hamilton.* But on this bittersweet occasion, the little show of that evening primrose brought me tears of joy.

Gloria Plevin
August 14, 2018

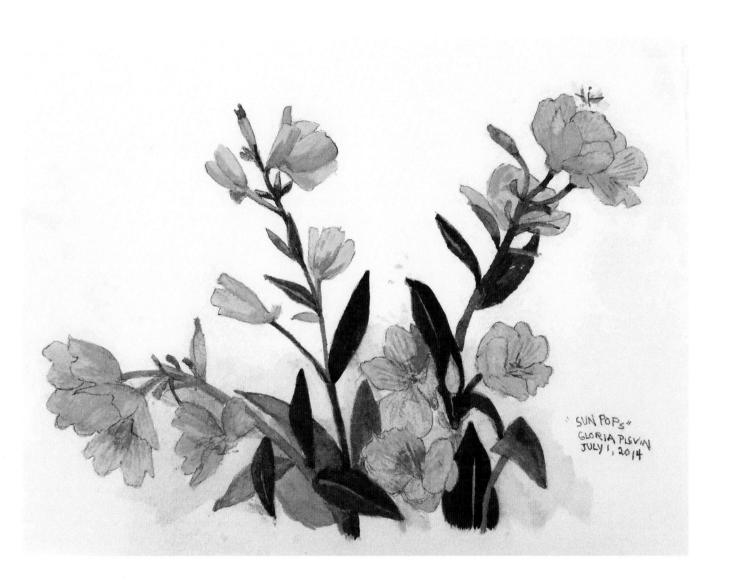

Sunpops (primrose family) 2014
Watercolor 9 x 12 inches

SNOW

I have never experienced a winter without snow.

When Buffalo art critic Anthony Bannon visited my studio and gallery in Chautauqua County, he compared my paintings with works of the Canadian Impressionists.

My conversation with Bannon about the spiritual quality in Northern painters, helped me realize that I share a Northern sensibility.

I have been thoroughly delighted by looking at paintings of snow by Claude Monet and George W. Bellows and woodblocks by Japanese artists.

For several years, snow scenes of Chautauqua County have been a part of my explorations in paint, pastel and etchings of all seasons of the year.

Up to 300 inches of snow fall on Chautauqua County each winter.

Gloria Plevin

JoJo, First Snow (right) 2013
Pastel 20 x 14 inches

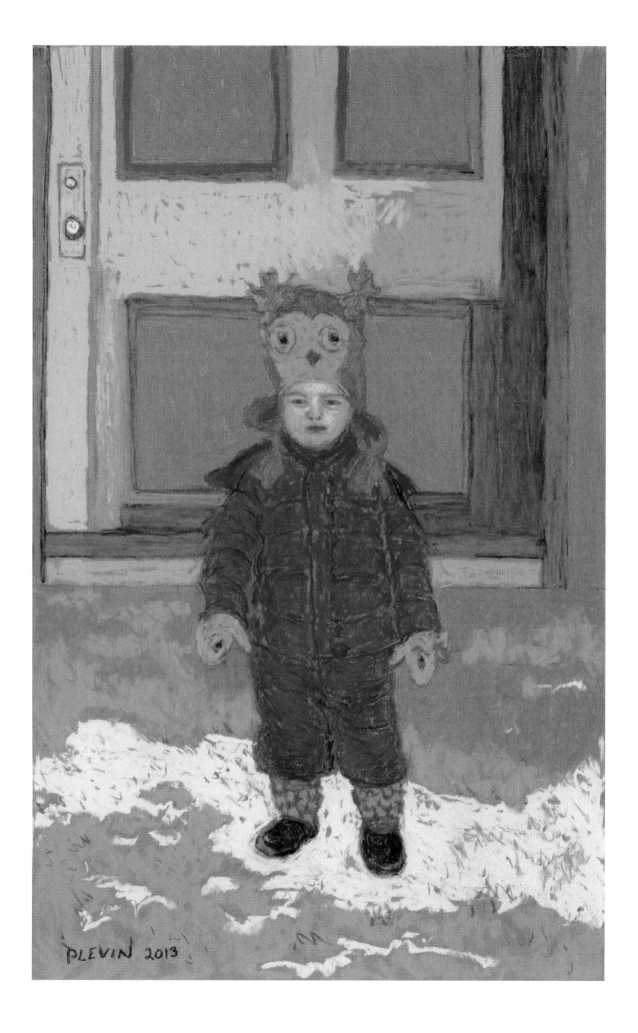

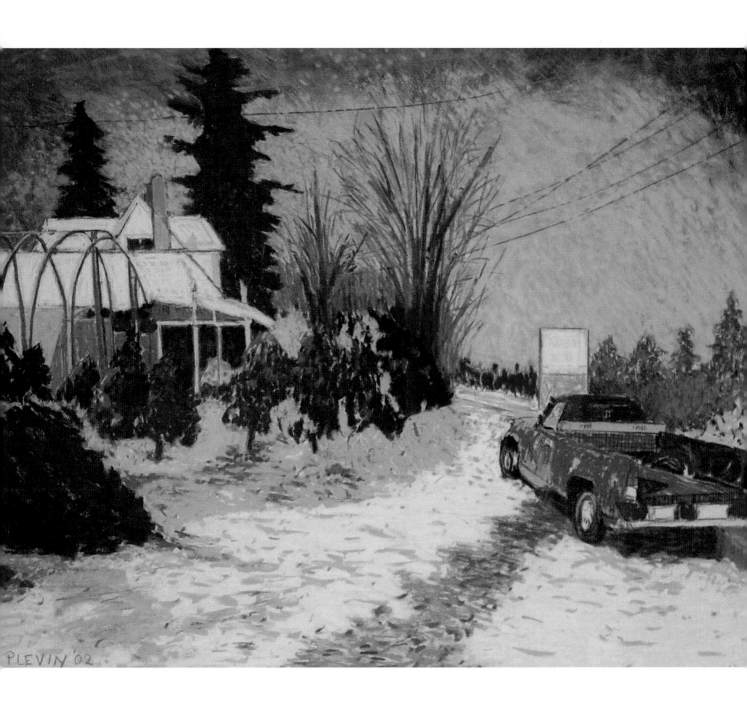

Christmas Tree Sale at Haffenden's (above) 2002
Pastel 17.5 x 23.5 inches
Courtesy of ARTneo

Snowy Hillside Over Lake Chautauqua (right) 2002
Pastel 17.5 x 23.5 inches

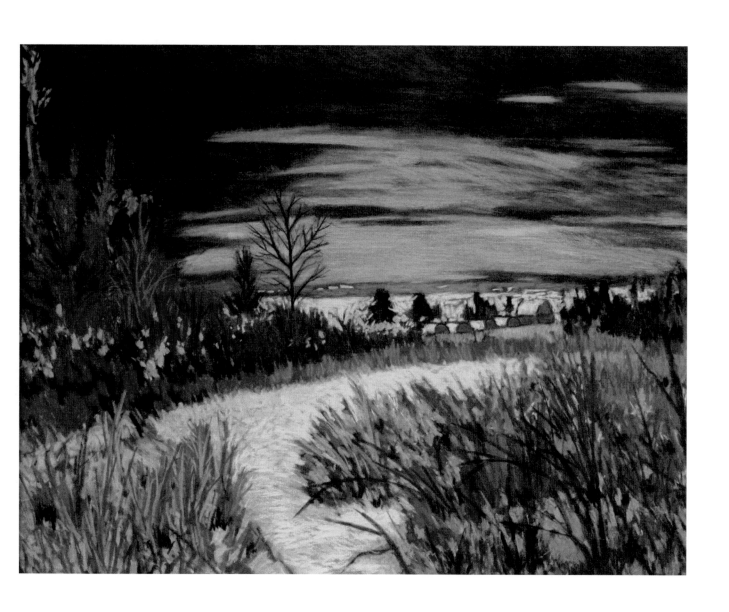

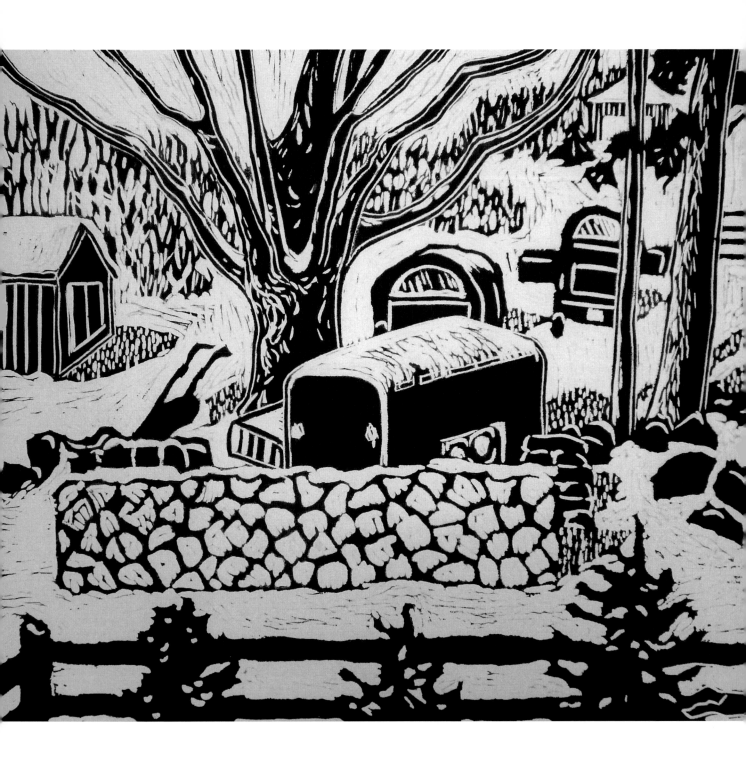

A Country Yard in Winter (above) 2001
Linoleum block print 20 x 26 inches

Chautauqua Winter Day (right) 2001
Etching 4.5 x 4.33 inches

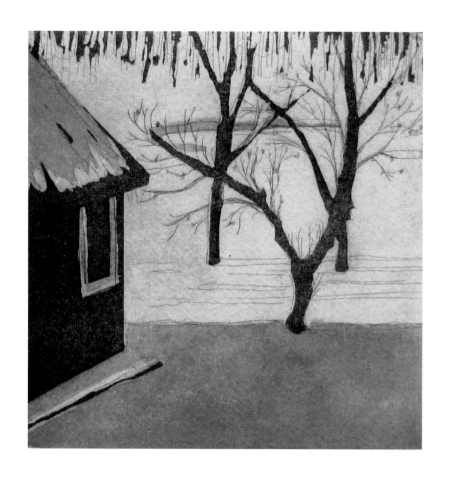

How I Learned to Love Japanese Prints

In the morning, a cricket chirped in the threshing room where Michael Verne would soon install the Japanese prints he was bringing from his Cleveland showroom to my summer gallery in Chautauqua. I imagined that the never-before-heard cricket was a sign of good luck.

Throughout that weekend, Leon and I joined many enthusiastic gallery visitors to listen, look, and learn from Michael as we admired his collection of classic and modern Japanese prints. That weekend was my introduction to these delicate, humane, exquisite works of art. From then on, we invited Michael to sell his works at the gallery for one weekend each summer, and each year, my love for the prints grew.

While traveling to London with the Cleveland Museum of Art Print Club a few years later in 1997, Leon and I saw a Royal Academy exhibit of masterworks by the Japanese printmaker Hiroshige entitled *Images of Mist, Rain, Moon and Snow.*

This was my first experience with Hiroshige's work. Enthralled, I later discovered a book of his famous series *The 53 Stations of the Tokaido* in which the artist made prints depicting the enormous public activity at each stop on the famous 18th Century travel route between Kyoto and Edo.

Not being skiers, Leon and I rarely visited Chautauqua in winter. When we did, we saw all sorts of business enterprises relating to summer and winter activities along Route 394. With snow piled high beside the recently plowed road, I drove to one winter establishment after another, camera in hand. It was early on a Sunday and every stop seemed deserted. I did not miss or need to see people for the prints and paintings I planned to make from these photos. Returning to Cleveland, I approached Kelly Novak, a young artist printmaker at Zygote Press, with snapshots in hand. Together, inspired by Hiroshige and the other Japanese printmakers I loved, we created the series of intaglios *One Snowy Day on Rte 394.*

Gloria Plevin
June 11, 2018

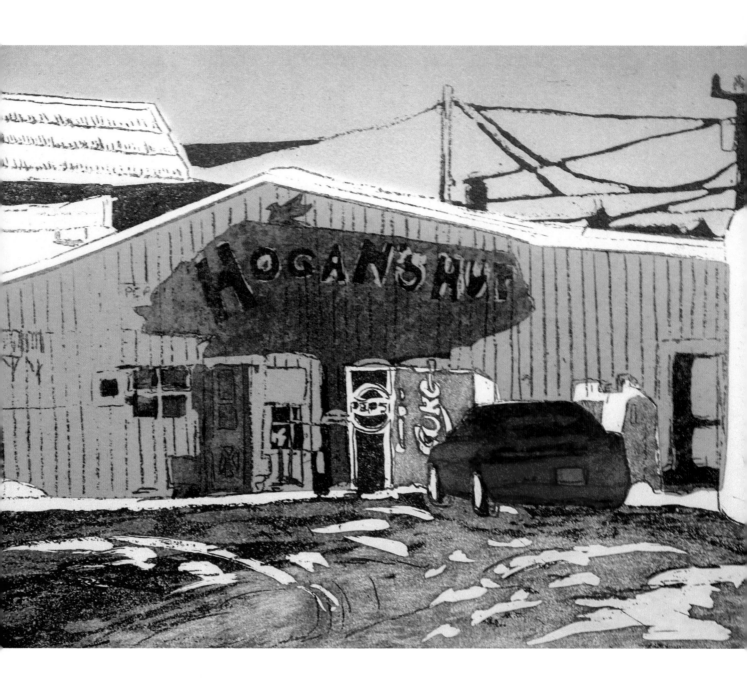

One Snowy Day on Rte 394, Hogan's Hut 2004
Intaglio print 7.75 x 10.75 inches

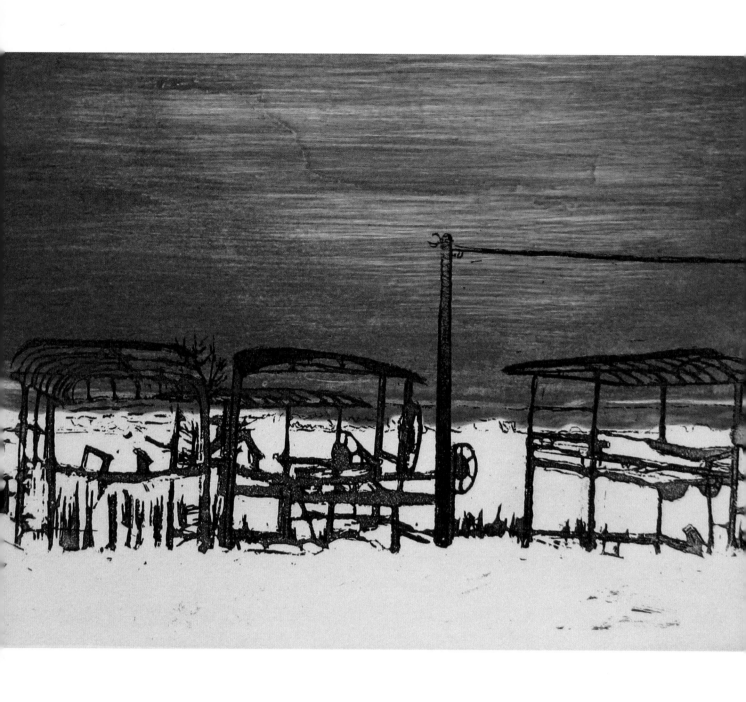

One Snowy Day on Rte 394, Cradles (above) 2004
Intaglio print 7.75 x 10.75 inches

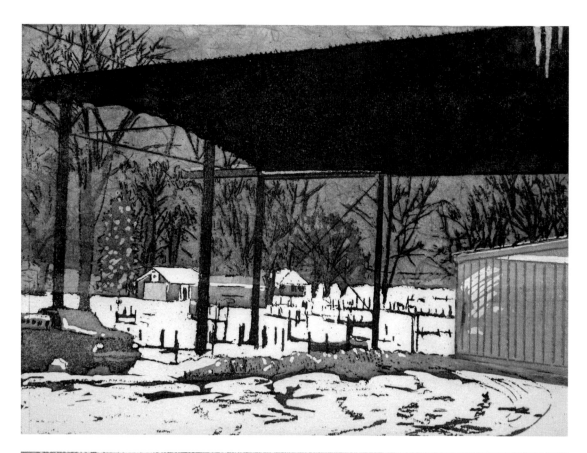

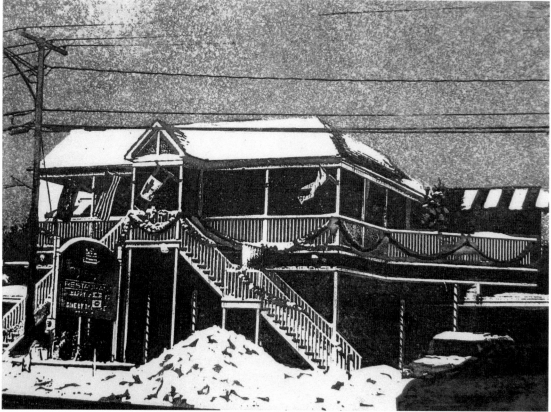

One Snowy Day on Rte 394, Marina (above) 2004
Intaglio print 7.75 x 10.75 inches

One Snowy Day on Rte 394, Webbs (below) 2004
Intaglio print 7.75 x 10.75 inches

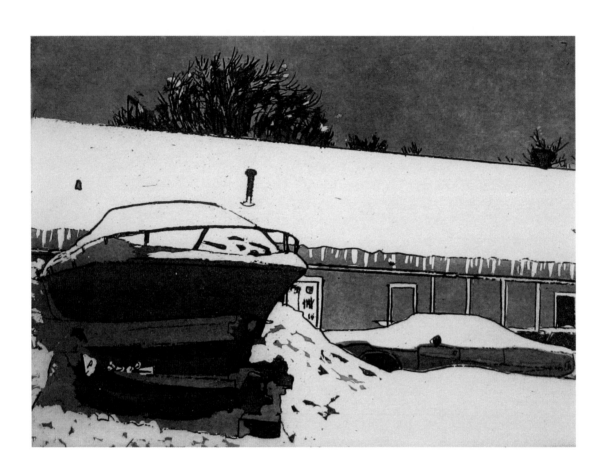

One Snowy Day on Rte 394, Snowed In (above) 2004
Intaglio print 7.75 x 10.75 inches

Breakfast at Dick's Harbor House (right) 1998
Pastel 20.5 x 26 inches

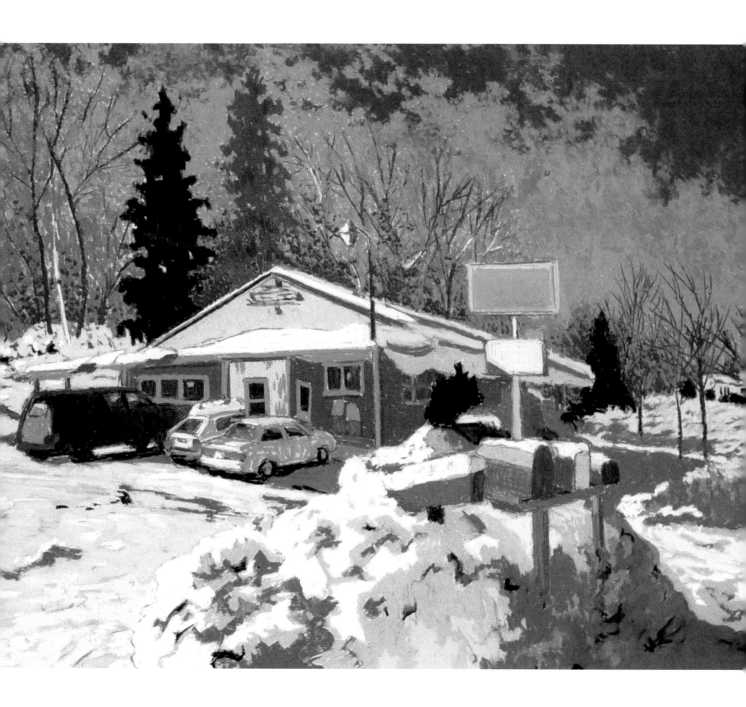

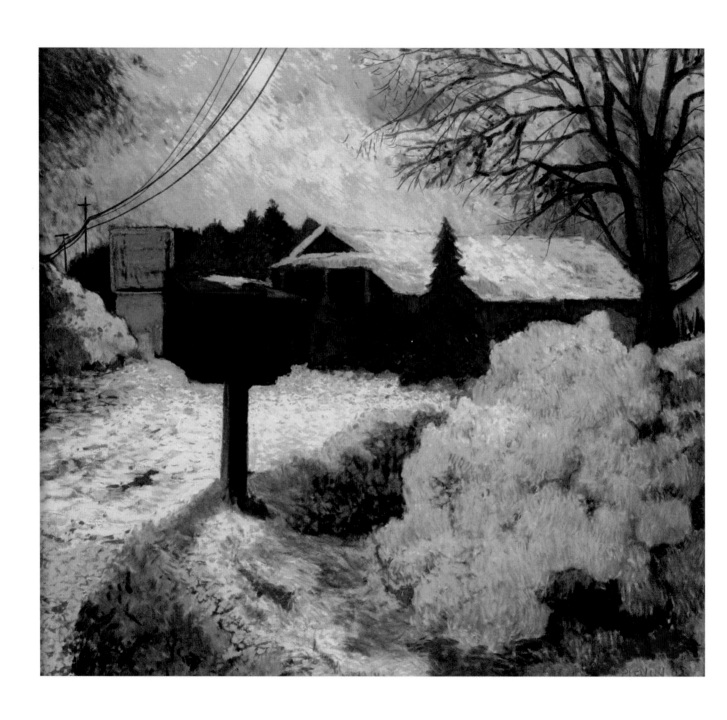

Snow Piles at Haffendens (above) 1995
Pastel 26.25 x 27 inches

Winter Woods (right) 1993
Monoprint 14 x 14 inches

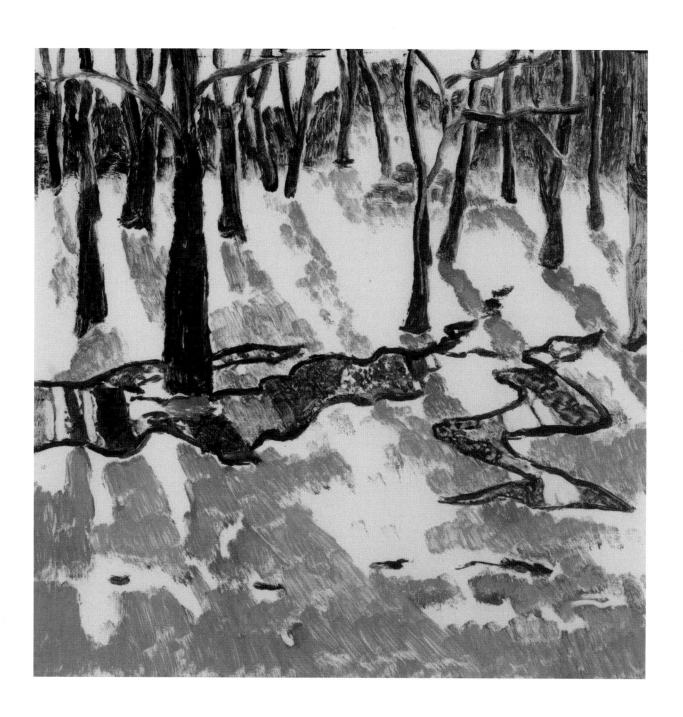

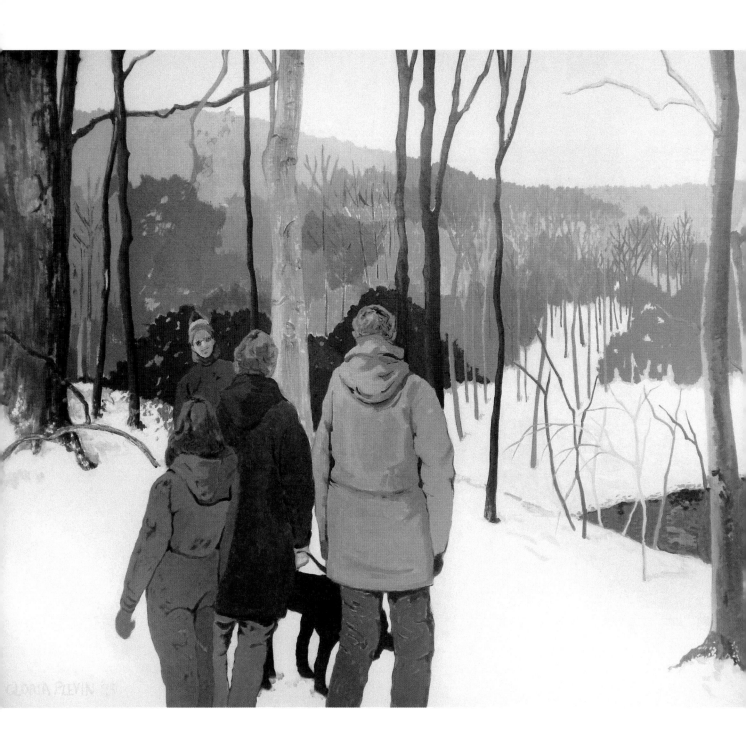

Winter Walk 1993
Acrylic dyptich 48 x 142 inches

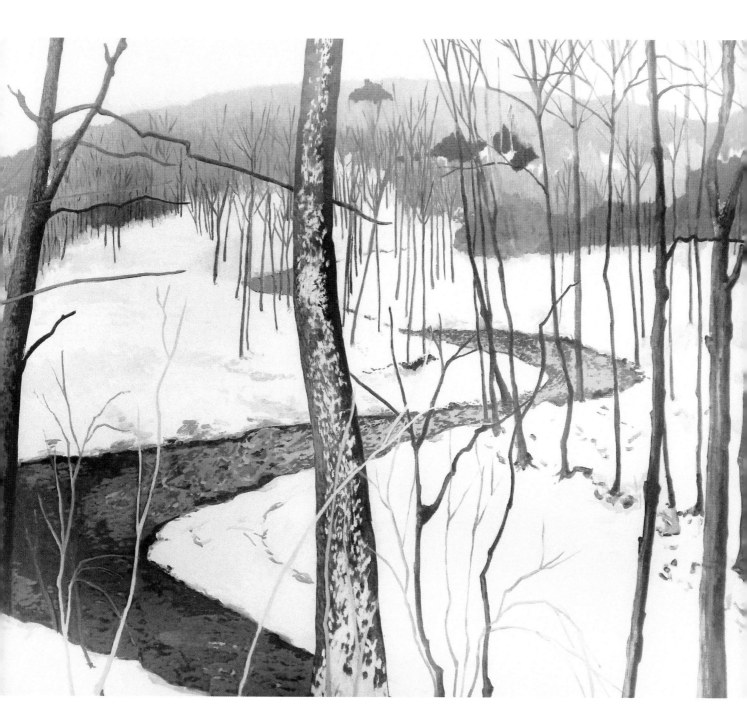

A Walk in the Woods

A walk in our winter woods was almost magical. There was a path upwards to follow where fallen dark brown tree trunks had been cut up, with some logs carted away to be fuel and others left to shelter animals. The path was quiet with a beautiful white stillness, a stillness when no turkeys were about and the deer were hiding somewhere else. Far up the hill was a makeshift log bench where one could sit, look out, and see down to the winding Chautauqua gorge. Our black standard poodle Charlie might bark at a squirrel, and one might be reminded of a walk in the woods of West Virginia.

Gloria Plevin
October 27, 2018

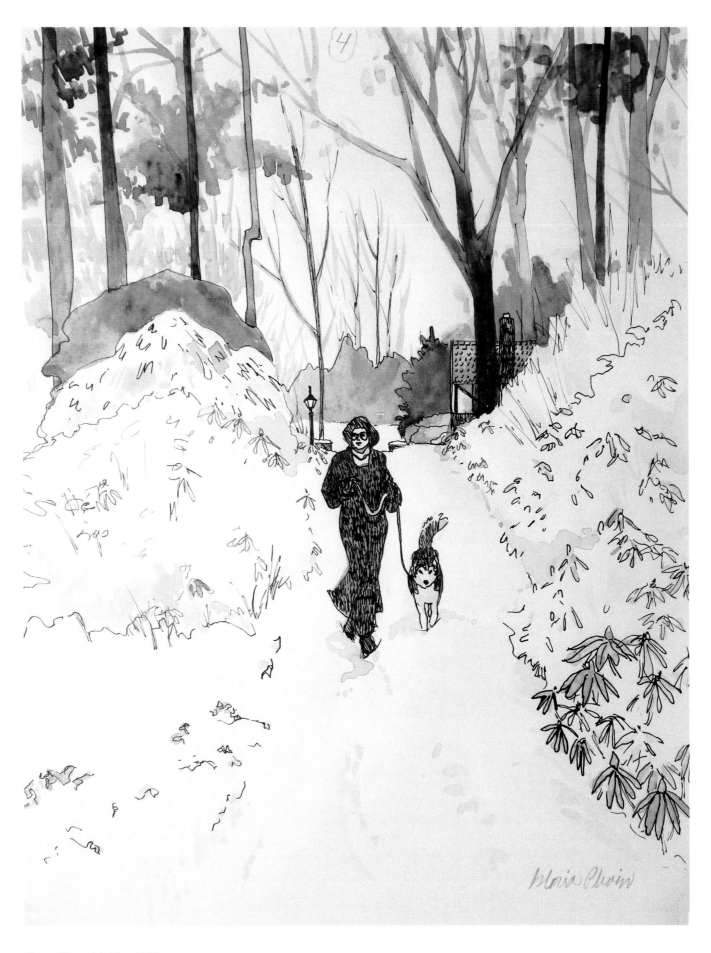

Snowy Day with Alexi 1999
Pen and ink 18 x 12 inches

Razzle-Dazzle

On Tuesday, February 22, 2011, Clevelanders woke to a fairyland of icy beauty. Overnight, Mother Nature had worked tirelessly to create a phenomenal show. Visually stunned, I drove up Shaker Boulevard toward a 9 a.m. appointment at the Hound's Hair dog groomer on Miles Road. Kim had assured me that she had heat and electricity; the roads had been superbly cleaned right to the blacktop, and the sun was shining. No good reason to stay at home.

The morning sun illuminated a world of snow and ice. No tree or bush had been spared. Already tufted with snow, everything growing had then been sheathed with ice. Each limb and leaf, no matter how thick or thin, and no object, large or small, had been overlooked.

Mother Nature had remembered the fringes on the shimmy dresses of red hot mamas at Prohibition clubs. She had envied the jingle-jangle bells adorning the leather costumes of dignified Indian women at pow-wows. Like any great artist, she interpreted and, with a brilliant stroke, created tiny icicles, three to five inches long, hanging from each and every telephone line. Each icicle caught the morning sun; the electric lines (never noticed except by migrating barn swallows) were now fringed with subtle and exquisite jewels. Millions, nay, billions of tiny icicles were strung ad infinitim in a beyond-human effort.

I drove down Richmond Road where the now all-white parking lot of a major mall had been planted with evenly-placed small trees. Every tree was covered with snow and ice with the precision and ravishing glamour of a Busby Berkeley extravaganza. I could imagine the tall, languorous, white-feathered and sequined dancers in perfect formation descending downward and moving upward in a totally white set as the music played "I'll Build a Stairway to Paradise."

Near the highway, a bowl-shaped bush about five feet high glowed with a fierce brilliant energy. Moses' bush which burned with fire but was not consumed, had been corrupted to clear, icy, brilliant theatricality. Could God be here, dare I ask, but we did not know it?

Friends recall with awe and excitement this sparkling, all-white morning. The confluence of bitter cold, warming, then icy rain, then frost, had followed a terrible snow and ice storm the previous day, when vehicles careened off thruways and a driver whose truck flew off the side of a bridge, was killed.

But my artist's mind has memorized the shimmering and sublime beauty of that icy morning. Using the prerogative given to humans, I name it "Mother Nature's Razzle-Dazzle."

Gloria Plevin
February 25, 2011

House in December Snow 1989
Watercolor 8 x 5 inches

A Mystery

There she was— like Sleeping Beauty— tucked under a clean white sheet and blanket on a white mattress, wearing a pretty white, sleeveless nightgown to cover her dark skin. Curled on her side, she slept with an expression of dreamy contentment.

A small line of trees, tall weeds and a wire fence surrounded her sanctuary which was tucked between my studio building's parking lot and the freeway entrance ramp. Her pristine mattress was surrounded, strangely, by overflowing trash cans, wads of torn magazines and crumbled wrappings. The effect was one of subterfuge, rejection and hiding. Why?

When I returned to my car a few hours later, her mattress was empty except for a neat pile of clothes and the messy papers. I also noticed a rather nice comfy chair nearby. The mystery space was beginning to feel like 'home.'

I began to imagine what had brought her here: Was she hiding from an angry, aggressive husband? Had she been evicted for not paying rent? Could she have scattered that garbage around her to hide her location? My desire to help was countered by my fear of doing harm. So I drove off that day without asking the building elevator operator or management about what I'd seen.

The next morning as I turned my car into the street beside the same lot, I saw a couple walking a small dog. The young woman looked vaguely familiar. Later, I wondered if she might be the occupant of the hidden outdoor bedroom who, for whatever reason, had slept there temporarily but was now taking a walk with her sweetheart, manager, photographer or mysterious partner.

A few days later, the weather changed: Autumn winds blew the temperature down to the 50's and into the 40's or lower at night. The mysterious outdoor bedroom now looked abandoned. All that remained were the mattress, a bit of sweater, and scattered trash. So perhaps its resident had been evicted with nowhere else to go for a time— like the one who sleeps in a doorway or under a bridge or the homeless child whose mother is in a difficult spot.

That day, I talked with our freight elevator operator Steve who has quietly observed the comings and goings in our parking lot for decades. He told me that, on the previous Sunday, a social worker and an officer with a gun had questioned someone in that open-air chamber. By then, a sturdy green tent had been pitched to cover the mattress. Steve added that this wasn't the first time the space had become someone's campground.

I'll never know Cleveland Sleeping Beauty's true story: She didn't return and her tale remains a mystery. But she does remind me how lucky I am. While luck may be elusive and surprising, we who have it may knock on wood or say 'poo poo,' throw salt over a shoulder or even say a prayer of thanks.

As I struggle with my own anxieties in this time of much uncertainty, a few days ago, I came across a production of The Sound of Music on TV. Seeing it reminded me that my high school class sang "Climb Every Mountain" at our graduation. It may seem hokey, but I was thrilled then and again now to hear its message. The book of my art is nearly done, and I know I can complete it.

Gloria Plevin
November 12, 2018

Fog

Everything out-of-doors is sparkling on this bright October day in Cleveland, but it was not so this morning, and it is this morning, wrapped in fog, that my brain and heart must remember.

Before 8 a.m., my 14-year-old miniature schnauzer Sammy and I emerged from Moreland Courts into a world wrapped in a pale, cloudless scene of gray tinted with the lightest shade of gray dipped in pale blue. No clouds or variety of shades or thickness, just an even gray mist everywhere.

Immediately, my artist brain declared, "Now here is a work of art." Since there was no famous artist about, it was up to me to record and share the scene:

On my right, the fog is not just in the sky; it has enveloped the tall trees of Shaker Boulevard's median so that three trees are modulated: The closest is dark black, the second medium black, and the third pale black as in a painted landscape. And while I study the trees, to my left, a steel gray rapid transit train comes tooting, chugging and charging into view along its iron tracks. Near the intersection, street lamps blur whitish-gray while traffic lights blink red and green, jewel-like in the fog.

Now deaf and nearly blind, Sammy meanders beside me, sniffing in his schnauzer way. Crisp oak leaves, gold and tan underfoot, cling to his black nose and furry paws. A brown squirrel eats and buries tiny acorns, fortifying herself for the winter to come.

In the next few days, each time I mention the fog, another acquaintance says, "Oh, 'Fog,' the poem by Carl Sandburg," and proceeds to recite it. Since my childhood did not include this poem, I looked it up and learned Carl Sandburg wrote it in 1916 based on a book of haiku carried in his hip pocket on a day when he was bored.

Gloria Plevin
October 16, 2017

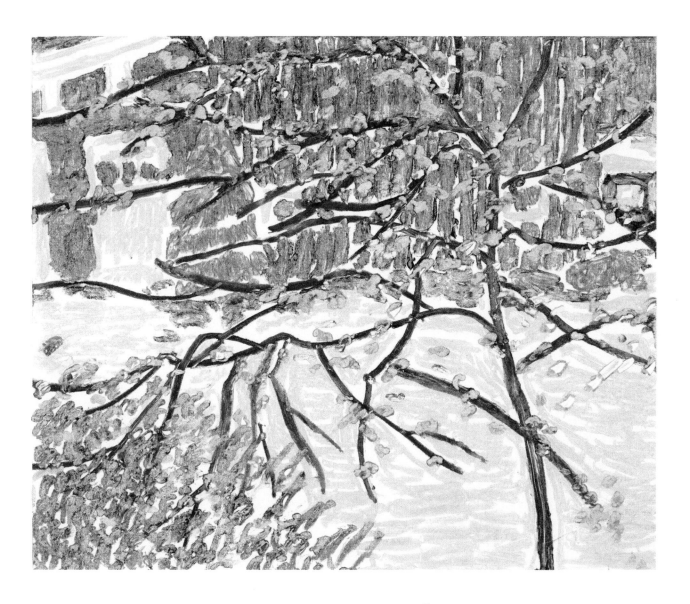

Fog

*The fog comes
on little cat feet.*

*It sits looking
over harbor and city
on silent haunches
and then moves on.*

— Carl Sandburg

Fog 2003
Monoprint 8 x 10 inches

What About Love?

My parents married on their third date. According to my dad Sidney who explained his theory to his only daughter, me, the bell has to ring for both people at the same time or, later on, that bell will ring for one of them with another person. I think this view of married love is as logical as one can uncover about the greatest mystery on earth. So, I still wonder: What is love? How does it abide in the human heart?

Now that I am 83, I'm quite aware of my beating heart which has a quixotic defect called atrial fibrillation. This heart slows me down and shortens my breath, reminding me that my days are numbered. The Bible tells us that life in full lasts 80 years. Because of the long life that I've mostly enjoyed, I'm filled with love despite my age. I miss Leon, my late husband of 52 years. Yet I love my children and grandchildren and, verily, I love old friends and also new friends whom I can embrace and give love and receive it back in turn.

Not far from my window, an old gingko soars upward. Tiny bluets push up through new green grass. Anticipating his mate's arrival, a woodpecker prepares his nest in the hole of a tree. The return of life from dormant winter is a miracle and in humans, gingkoes, bluets and woodpeckers, that force of renewal is love.

Gloria Plevin
May 9, 2018

Gloria and Grandsons (left)

Gloria's 80th Birthday in Chautauqua (above)
Photo by Heather Woloszyn

IN APPRECIATION

I had just completed *Conversation on Potter Road*, my first large painting of a Chautauqua scene. One by one, first Leon, then each of our four children took a peek into my home studio and said, "It's good, Mom! Very nice, Mom!"

I realized then how much I needed a larger audience and—more than just an audience—art associates who could discuss my work and confer about their own. With envy, I imagined French painters gathered around cafe tables drinking, eating and arguing!

To satisfy this longing, I joined NOVA (New Organization of the Visual Arts), The Cleveland Museum of Art Print Club and, eventually, the Cleveland Artists Foundation (now ARTneo) and the Artists Archives of the Western Reserve. Through interacting with this fascinating mix of artists, scholars, and collectors, I became an active part of Northeast Ohio's vibrant arts community, greatly fostering my creative growth and career. I'm especially grateful to Jane Glaubinger, the Cleveland Museum's print curator and Print Club director, who's become a close friend and introduced me to the world of prints.

I want to thank ARTneo, the museum for Northeast Ohio art, for publishing this book and mounting the large retrospective of my work that preceded it. Guided by curator Christopher Richards' exquisite taste, the crew from M. Gentile elegantly installed 60 paintings and prints I completed between the 1970s and the present. Rooms and hallways beckoned visitors with a wide variety of landscapes, portraits, still lifes, and botanicals. I was deeply touched to see the many ways my paintings affected not just friends and family but also viewers I'd never met before. Thanks as well to ARTneo board president Sabine Kretzschmar, past president Joan Brickley, and 78th Street Studios owner Dan Bush for their support.

I'm doubly grateful to consultant Bill Busta—first, for writing an intriguing article in CAN Journal about my upcoming exhibit, which also serves as this book's introduction; and second, for interviewing me in a delightful conversation at ARTneo surrounded by my paintings and a packed room of visitors.

I greatly appreciate the skills and hard work of my incredibly talented book designer Joyce Rothschild. In working directly with me rather than with the publisher, her usual method, Joyce has been patient, inventive, kind, and adamant when needed.

My daughter Mimi Plevin-Foust has been my sharp-eyed editor and proofreader. Her prose-poem *$24 and a Watch* is a moving complement to the portrait of my father-in-law Ben Plevin on pages 22-23. She has already made a fine eight-minute video about my art career and Chautauqua gallery which is posted on YouTube.

Gloria
Photo by Keith Berr (©keithberr.com)

James Wehn catalogued all the art I've produced since the 1960s, a huge undertaking which laid the foundation for both my ARTneo retrospective and this book. His careful expertise has been invaluable.

The excellent photos of my art and my studio that fill this book were taken by Fuchs and Kasparik, M. Gentile Studios, Barbara Weiss, Christopher Richards, and other photographers.

I wrote several of these essays to meet deadlines offered by the writers' group I've been part of for two years. I am so grateful to its organizers Julie and Louis Handler and to my fellow writers for their enthusiasm and support.

Few artists are fortunate enough to share studio space with another artist who becomes a best friend and helpmate for over 20 years and makes suggestions only when asked. Bonnie Dolin and I have had long marriages: We took that as an omen for success when we agreed to share a studio in the Artcraft Building on Superior Avenue. I am especially grateful for Bonnie's companionship, generous nature, sense of humor, and fine artistic sensibility.

My four children and their spouses, my seven grandchildren, and our extended family have cheered me on as I completed this book. Many friends have been supportive, but especially Arnold Berger, Fran Heller, Bea Blumenthal and Pearl Livingstone. I could write at length about the lifelong support and encouragement I received from my late husband Leon, but I hope I've shared my gratitude to him throughout my essays.

In parting, I want to thank the English artist David Hockney who's been an important teacher for me although we've never met. In his book *That's the Way I See It*, he defends his work from the critics who say it's 'too pleasant,' a comment I've received as well. As Hockney notes, such critics are not looking carefully. I'm also grateful to the visitor to my retrospective who said his favorite painting was my portrait of Leon drinking coffee because he noticed I'd painted several chest hairs peeking out from Leon's shirt.

Gloria Plevin
October 4, 2018

CHRONOLOGY

Gloria Plevin

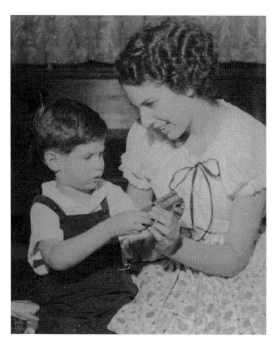

*Gloria at 12 with her two-year-old brother Barry,
late 1940's after WWII.*

Born

1934 Born in Pittsburgh, PA; raised in Clarksburg, WV

Selected Education

1952 Washington Irving High School, Clarksburg WV

1954 Associate of Arts Degree, Ohio University, Athens, OH

1968–83 Chautauqua School of Art, Chautauqua, NY

1968 Thelma Frazier Winter, Jewish Community Center,
Cleveland Heights, OH

1975-85 Cleveland Institute of Art & Cooper School of Art, Cleveland, OH

1981-82 Albert Handel Workshops, Cleveland, OH

1999 Charles Basham Workshop, Cleveland, OH

Professional Experience

1954-57 Assistant Buyer, Sterling Linder Davis, Cleveland, OH

1986 TO 2002 Owner/Director, Gloria Plevin Gallery, Chautauqua, NY

Listed as 'Must-See' in *The 100 Best Small Art Towns in America*
(John Villani, 1996)

Museum Collections

Art Museum of West Virginia University, Morgantown, WV

ARTneo: The Museum of Northeast Ohio Art, Cleveland, OH

Butler Institute of American Art, Youngstown, OH

Burchfield Penney Art Center, Buffalo, NY

Cleveland Museum of Art, Cleveland, OH

Studio in the Barn
Etching

Selected Exhibitions

2019 Gloria Plevin, Gallery at Moreland Courts, Cleveland, OH

2018 Gloria Plevin: A Life in Art, Solo Retrospective, ARTneo:
The Museum of Northeast Ohio, Cleveland, OH

Artists Archives, Mansfield Art Center, Mansfield, OH

2016 The Flowering of the Botanical Print, Cleveland Museum of Art,
Jane Glaubinger, Curator, Cleveland, OH

2013 Hidden Treasures: Paintings & Prints by Gloria Plevin,
The Verne Collection, Cleveland, OH

Legacy Invitational Show, Artists Archives of the Western Reserve,
Cleveland, OH

2012 Gloria Plevin: Portraits in Nature, West Virginia University,
Morgantown, WV

Orientations, Fiori Gallery, Cleveland, OH

Legacy Invitational Show, Artists Archives of the Western Reserve,
Cleveland, OH

2011 Gloria Plevin: Botanicals of Flowers, Roger Tory Peterson Institute,
Jamestown, NY

Gloria Plevin: Flowers, Cleveland Botanical Gardens, Cleveland, OH

2010 Iconic Chautauqua Landscapes, Portage Hill Gallery, Chautauqua, NY

Printmaking Exhibition Project, traveling exhibit of Zygote artists (ongoing),
Northeast Ohio

2009 Shaker by Shaker, Shaker Arts Council, Library Art Gallery,
Shaker Heights, OH

2008 Gloria Plevin: Prints, Zygote Press, Cleveland, OH

2007 Gloria Plevin: The View from Here, Mid-Career Retrospective,

Logan Gallery, Chautauqua, NY

Drawing Invitational, Kendal at Oberlin, Oberlin, OH

Over 65 Invitational, Cuyahoga Community College East, Highland Hills, OH

2004 Women's Invitational: Gloria Plevin and Bonnie Dolin, Wasmer Gallery,
Ursuline College, Cleveland, OH

Worlds Apart, Gloria Plevin & Phyllis Seltzer, Artists Archives of the
Western Reserve, Cleveland, OH

Works on Paper, Verne Collection, NY Armory, New York, NY

2002 Gloria Plevin: Aspects of Home, Gloria Plevin Gallery, Chautauqua, NY

Botanicals and Landscapes: Paintings by Gloria Plevin, Kelly Randall Gallery,
Tremont, OH

Objects that Don't Move, Artists Archives of the Western Reserve,
Cleveland, OH

2001 Gloria Plevin, Shoreby Club, Bratenahl, OH

Plevin, Rosenbluth & Friends, Gloria Plevin Gallery, Chautauqua, NY

Sara Naps in Tokyo
After growing up in the small West Virginia towns of Weirton and Clarksburg, Leon and I wanted our children to gain a broader perspective. Through the Council of World Affairs, we brought more of the world into our Cleveland home by 'adopting' and socializing with a series of visiting foreign doctors and their families while they lived here.

These families hailed from China, Belgium, Australia and Japan. Later, Leon and I toured many countries with the Cleveland Museum of Art's Print Club. A highlight of our travels was an independent trip to Japan and Thailand with Sara, Mimi and her husband Bill. Our excuse was a chance to visit and stay with our son Andrew, then in his twenties and fluent in Japanese, during the three years he worked in Tokyo. I sketched Sara napping in his apartment in Yoyogi Uehara after our 26-hour journey to get there.

Print Invitational, Dead Horse Gallery, Lakewood, OH

1999 Gloria Plevin: Into My Yard (and other adventures), The Intown Club, Cleveland, OH

Three Views with Gail Newman and Phyllis Sloane, JCC of Greater Washington, Rockville, MD

Prints, Prints, Prints: Bonnie Dolin and Gloria Plevin, Artcraft Building, Cleveland, OH

Waterscapes, Mansfield Art Center, H. Daniel Butts, III, Curator, Mansfield, OH

First Ohio Print Biennial, Cleveland Artists Foundation and Zygote Press, Beck Center, Lakewood, OH

1998 Fields and Flowers: Jursinski & Plevin, Cleveland Playhouse Gallery, Cleveland, OH

Women Artists of Northeast Ohio: Past and Present, Cleveland Artists Foundation, Lakewood, OH

1997 Gloria Plevin: Still Life (Vividly Alive), Gloria Plevin Gallery, Chautauqua, NY

Vessels and Views with ceramicist Thivo, Beachwood Arts Council, Beachwood, OH

1996 On Common Ground, Gloria Plevin Gallery, Chautauqua, NY

1995 Gloria Plevin: Chautauqua Vistas, James Prendergast Library Art Gallery, Jamestown, NY

Landscape, Landscape, Brenda Koos Gallery, Cleveland, OH

1994 Gloria Plevin: Chautauqua Vistas, Gloria Plevin Gallery, Chautauqua, NY

My Friends, The Verne Collection, Cleveland, OH

1993 Gloria Plevin: Chautauqua Still Lives & Vistas, Butler Institute of American Art, Salem, OH

1992 Gloria Plevin: Watercolors and Monoprints, Saint Paul's Episcopal Church, Cleveland Heights, OH

1991 Watercolors and Weavings with daughter Ann Plevin Rosenbluth, Humphrey Atrium Gallery, University Hospitals, Cleveland, OH

1990 Barn Appétit, The Dairy Barn Arts Center, Athens, OH

1989 Gloria Plevin, Octagon Gallery, Patterson Library, Westfield, NY

Cleveland Watercolor '89, Great Northern Corporate Center, Cleveland, OH

1988 Gloria Plevin: Portraits, Laurel School, Shaker Heights, OH

American Drawing Biennial, Muscarelle Museum of Art, College of William and Mary, Williamsburg, VA

First International Painting Competition, Baltimore Jewish Community Center, Baltimore, MD

1987 Gloria Plevin, Karamu Theater Gallery, Cleveland, OH

1986 Inside/Outside with Jim George, Alan Gallery, Berea, OH

1985 Access Annual, Adams Memorial Gallery, Dunkirk, NY

Columbus Museum of Art, Members Gallery, Columbus, OH

Tri-State Invitational, CAA Galleries, Chautauqua, NY

1982 Gloria Plevin, Booksellers, Beachwood, OH

The Self-Portrait, Cleveland Art Festival, Cleveland, OH

1981 Gloria Plevin, Women's City Club, Cleveland, OH

Women Artists Look at Men, Beck Center for the Arts, Shirley Aley Campbell, Curator, Lakewood, OH

1980 Gloria Plevin, Octagon Gallery, Patterson Library, Westfield, NY

Paper Impressions, NOVA (New Organization for the Visual Arts), Bonfoey Gallery, Cleveland, OH

International All on Paper Show, AAO Gallery, Buffalo, NY

1979 Gloria Plevin, American Institute of Architects, Cleveland, OH

Gloria Plevin & Margarita Handel, Coventry Art Gallery, Cleveland Heights, OH

1978 In a Grand Manner, Women's City Club Invitational, Bratenahl, OH

1976 Bicentennial One-Person Show, Chautauqua Art Association Gallery, Chautauqua, NY

1975 Gloria Plevin, Octagon Gallery, Patterson Library, Westfield, NY

Chautauqua National Juried Show, Chautauqua, NY

21st Annual Art Show, Jewish Community Center, Cleveland Heights, OH

1974 Gloria Plevin, Women's City Club, Cleveland, OH

Mid-Year Painting Show, Butler Institute of American Art, Youngstown, OH

The American Face, Trumbull Art Guild, Warren, OH

Pots, Paint, Prints, Pen with Bea Blumenthal, Suzanne Gilbert & Doris Sugerman, Millcreek Racquet Club, Cleveland, OH

1973 Chautauqua National Juried Show, Chautauqua, NY

Selected Other Collections

Artists Archives of the Western Reserve, Cleveland, OH

BF Goodrich, Charlotte, NC

Chautauqua & Erie Telephone Corp., Westfield, NY

Cleveland Clinic, Cleveland, OH

Cleveland State University, Marshall College of Law, Cleveland, OH

Jewish Community Center, Cleveland, OH

MBNA Corporation, Cleveland, OH

Temple Emanu El, Cleveland, OH

University Hospitals, Cleveland, OH

Zygote Press Collection, Cleveland, OH

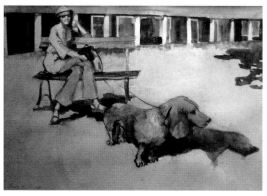

Portrait of Lillian (above)
Lillian, a dear friend and New York City school teacher who summered at Chautauqua

Lillian with Zelda (dachshund) at Chautauqua Art School (brlow)

Plevin Family (left to right: Sara, Gloria, Andrew, Ann, Leon, Mimi), taken at Ann's graduation from the School of the Art Institute of Chicago, 1981.

Selected Awards and Commissions

2003 Signature Artist, American Diabetes Association Annual Benefit, Cleveland, OH

2000 University Print Club etching commission, Cleveland, OH

1999 Governor's Award, Ohio Arts Council, Columbus, OH

1988 Best of Show, Jewish Community Center Annual, Cleveland, OH

1987 Juror's Commendation, Benefit for Independent Living, AAO Gallery, Buffalo, NY

1985 Purchase Award, Jewish Community Center Annual, Cleveland, OH

1984 Newman Religious Art Exhibit Award, for bridal canopy with collaborators Margarita Handel, Jack Tetalman and Zelda Roseman; Case Western Reserve University, Cleveland, OH

1976 First Prize and Honorable Mention, Bestor Plaza Art Festival, Chautauqua, NY

1974 First Prize in Portraiture, Bestor Plaza Art Festival, Chautauqua, NY

1973 Helen Logan Award for Traditional Painting, Chautauqua National Juried Show, Chautauqua Arts Association Gallery, Chautauqua, NY

Second Prize in Landscape, Bestor Plaza Art Festival, Chautauqua, NY

1972 First Place in Portraiture and First Place in Figure, Bestor Plaza Art Festival, Chautauqua, NY

1969 Honorable Mention, Bestor Plaza Art Festival, Chautauqua, NY

Chautauqua Porch Looking at Lake (above)

View from our Deck (below)

Exhibitions Curated

2005-2006 Visual Tales featuring Michelangelo Lovelace, Gail Newman and Paul W. Patton, co-curated with Rotraud Sackerlotsky, Cleveland Artists Foundation, Cleveland, OH

1999-2000 City Life, co-curated with Patricia Brigotti, Cleveland Artists Foundation, Cleveland, OH

Exhibitions Juried

2004 Hallinan Religious Art Show, Ursuline College, Cleveland, OH.

1995 Employee Photo and Art Competition, University Hospitals, Cleveland, OH.

1994 National Scholastic Competition, Cleveland Institute of Art.

1993 Faces of Cleveland photography competition with jurors Tom Hinson, Curator, Cleveland Museum of Art and Robert Thurmer, Director, Art Gallery at CSU, Cleveland State University.

Selected Bibliography

MONOGRAPH

McClelland, Elizabeth. *The Art of Gloria Plevin.* Cleveland, 1998.

OTHER BOOKS AND CATALOGS

Sackerlotzky, Rotraud and Roger Welchans. *The Archives Speak: Insights & Images of Ohio Artists.* Cleveland, 2014.

Ascherman, Jr., Herbert. *The Artists Project: 100 Portraits of Artists.* Cleveland, 2001.

Who's Who in American Art, 1997-1998, 2007-2008, 2010.

Portfolio '83, a Juried Selection of Visual Artists in the Cleveland Area, published by NOVA.

SELECTED ARTICLES

Jeff Piorkowski, "Exhibit shines light on Plevin's 53-year career," *Sun Newspapers, cleveland.com,* April 12, 2018. https://www.cleveland.com/shaker-heights/index.ssf/2018/04/plevin.html

William Busta, "Gloria Plevin at ARTneo: Transformed Through Selective Imagination," *CAN Journal,* Winter 2017-2018. http://canjournal.org/2017/11/goria-plevin-artneo-transformed-selective-imagination

Charlene Lattea, "Portraits in Nature by Gloria Plevin to Open June 17 at WVU," *WVU Today,* June 13, 2012. http://wvutoday-archive.wvu.edu/n/2012/06/13/portraits-in-nature-by-gloria-plevin-to-open-june-17-at-wvu.html

The Good Soup
Wherever we lived, our family ate dinner together. In Cleveland, Leon came home from his law office by 6 p.m. to join us. Mostly, it was just important to be there.

Emanuel Cavallaro, "The View From Here," *Chautauqua Daily,* June 26, 2007.

Steven Litt, "1 World, 3 Views," *Cleveland Plain Dealer,* December 29, 2005.

Steven Litt, review of *Parallel Lives, Cleveland Plain Dealer,* 2004.

Fran Heller, "Parallel Lives: A Tale of Two Artists," *Cleveland Jewish News,* October 29, 2004.

Lois Wiley, "So Long, Gloria Plevin Gallery," *Erie Daily Times,* August 2002.

Christian-Albrecht Gollub, "An Interview With Gloria Plevin," *Fresh Ink,* Zygote Press Newsletter, Fall/Winter 2002. http://www.christiangollub.com/gloria_plevin_int.html

Gloria Plevin, "Painter of Chautauqua County," *Artifacts,* Summer 2001.

Steven Litt, "Some Strong Works Dominate Offerings at Ohio Print Show," *The Plain Dealer,* October 21, 1999.

Ann Belcher, "Local Artist Gloria Plevin To Host Book Signing July 19th," *Mayville Sentinel,* July 16, 1998.

Lois Wiley, "A Walk in Sunlight," *Erie Daily Times,* August 13, 1998.

Steven Litt, "Good Start for Artists' New Venue," *The Plain Dealer,* April 26, 1998.

Lois Wiley, "The 'Ism' That Has Endured," *Erie Daily Times,* August 14, 1997.

Lois Wiley, "Art on Common Ground," *Erie Daily Times,* August 16, 1996.

Fran Heller, "Varied Menu in Group Landscape Show," *Cleveland Jewish News,* February 9, 1996.

Maida Barron, "Crowded Landscape," *Cleveland Plain Dealer,* February 9, 1996.

Adrienne Russ, "Artist Plevin's Landscapes are Creative, Deliberate," *The Sun-Press,* March 21, 1996.

Robert Plyler, "Colorful Landscapes Adorn Art Gallery at Prendergast," *The Post-Journal,* December 9, 1995.

Lois Wiley. "Art That's Fine to Live With," *Erie Daily Times,* August 10, 1995.

Helen Cullinan, "Friends Eclectic Exhibit Displays Styles of Japanese," *Cleveland Plain Dealer,* December 27, 1994.

Lois Wiley, "Plevin & Plevin & Plevin," *Erie Daily Times,* August 11, 1994.

Marilynne Northrup, "Plevin's Acrylics Immortalize Scenes of Rural Countryside," *Mayville Sentinel,* August 4, 1994.

Fran Heller, "Cleveland Artist Unleashes New Perspectives," *Cleveland Jewish News,* October 15, 1993.

Dick Wooten, "The Cleveland Connection," *Salem News,* October 7, 1993.

Helen Cullinan, "Plevin Displays a New Love," *Cleveland Plain Dealer,* 1993.

Helen Cullinan, "Life's Reflection's," *Cleveland Plain Dealer,* March 27, 1987.

Fran Heller, "Simple Things Inspire Plevin's Artistic Imagination," *Cleveland Jewish News,* May 6, 1988.

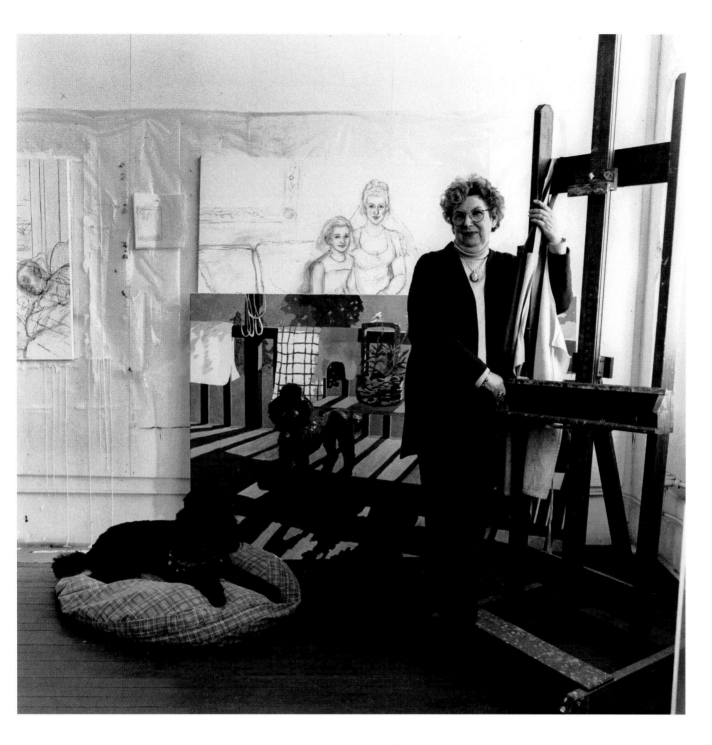

Gloria in the Studio Herbert Ascherman, Jr.
From his book *The Artists Project*, 2001

Films and Videos

Gloria Plevin: A Portrait of Life, ARTneo and Wide Time Productions, 2013.
https://www.youtube.com/watch?v=-iLtKxjPaR0

Nina Gibans, *Creative Essence 1900-2000,* Cleveland Artists Foundation, 2003.

The Oral History Project, Interview by James Ellis, Artists Archives, 2001.

Gloria Plevin: Still Lifes & Vistas, Butler Institute of American Art, 1993.

Collectors

ARTneo would like to thank the people and organizations who have graciously allowed reproduction of works from their collections:

Art Museum of West Virginia University

Artists Archives of the Western Reserve

ARTneo

John and Joan Brickley

Scott Brown

Burchfield Penney Art Center

Ruth Anna Carlson and Albert Leonetti

Gerald and Winnie Chattman

Cleveland Marshall College of Law

Jorge and Sara Cruz

The Dickerson Family

Jena Doolas

Henry and Roz Frank

Frank Gallucci and Michelle Stuhler

Joyce Gulden

Ken and Betsy Hegyes

Fran Heller

James and Christine Heusinger

Irving and Enid Kushner

David and Deborah Livingstone

Jon Logan

Patrick and Christine McCarthy

Louise Mooney

Warren and Betsi Morris

Lory Nurenberg

Alec and Tamara Pendleton

Andrew Plevin and Kendra Collins

Mimi Plevin-Foust

Sandy and Ann Rosenbluth

Mary Ryan

The Shibley Family

Steven and Diane Steinglass

Summa Health System

Temple Emanu El

Mirjanna and Branislav Ugrinov

Margy Weinberg

John and Cara Zoltowicz

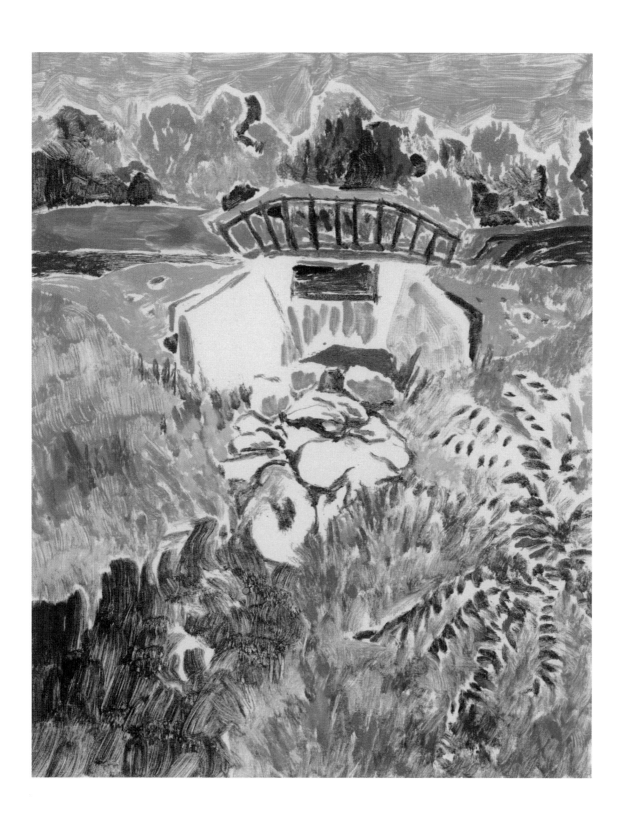

Going to the Farmers Market (left) 1977
Acrylic 61 x 24 inches

Little Bridge on the Golf Course Rte. 394 (above) 1993
Monoprint 14.75 x 12 inches

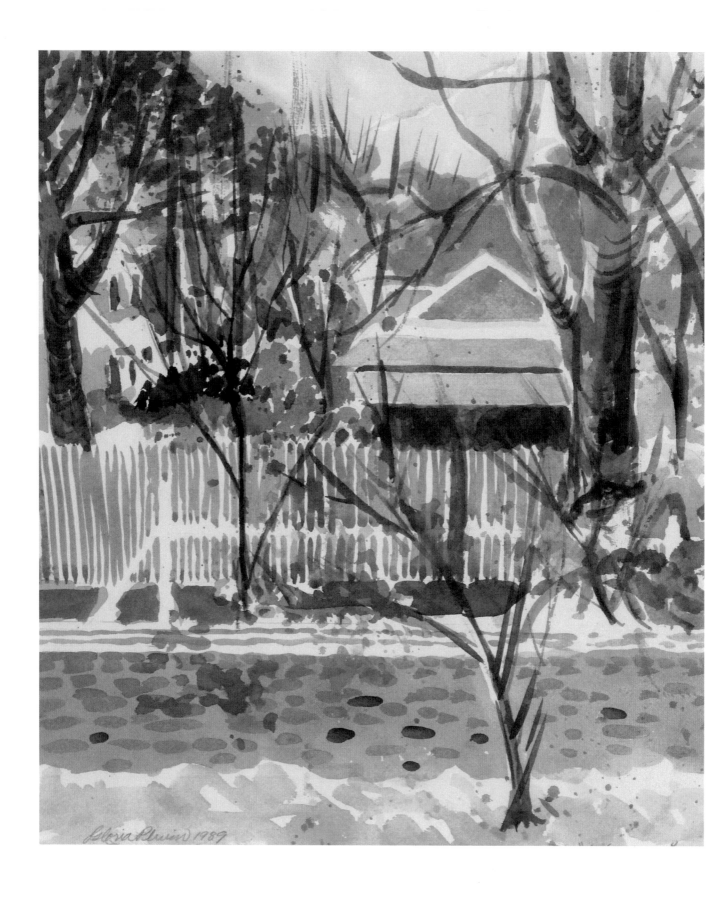

View from my Studio Window, Shaker Heights 1989
Watercolor 19 x 14 inches